HOW TO PAINT WITHOUT A BRUSH

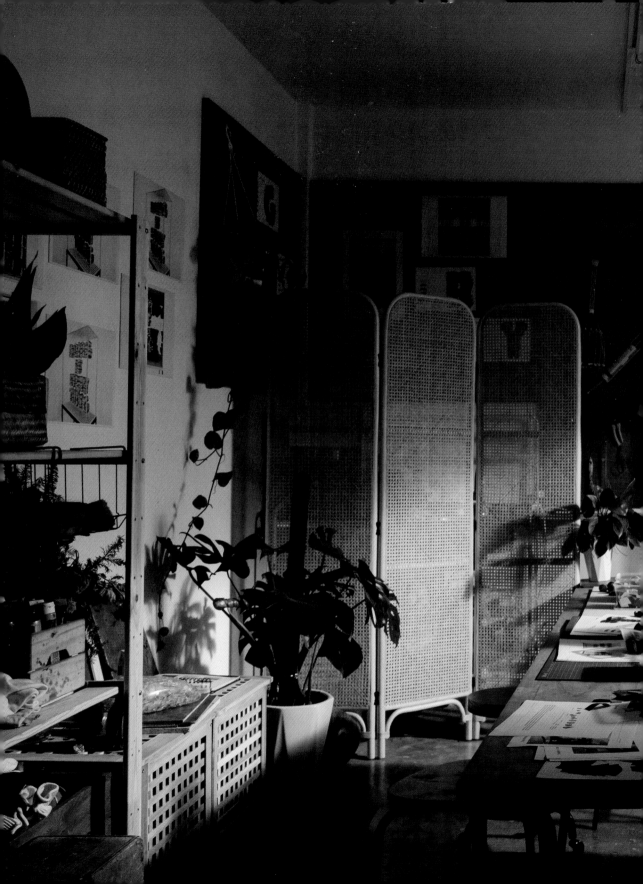

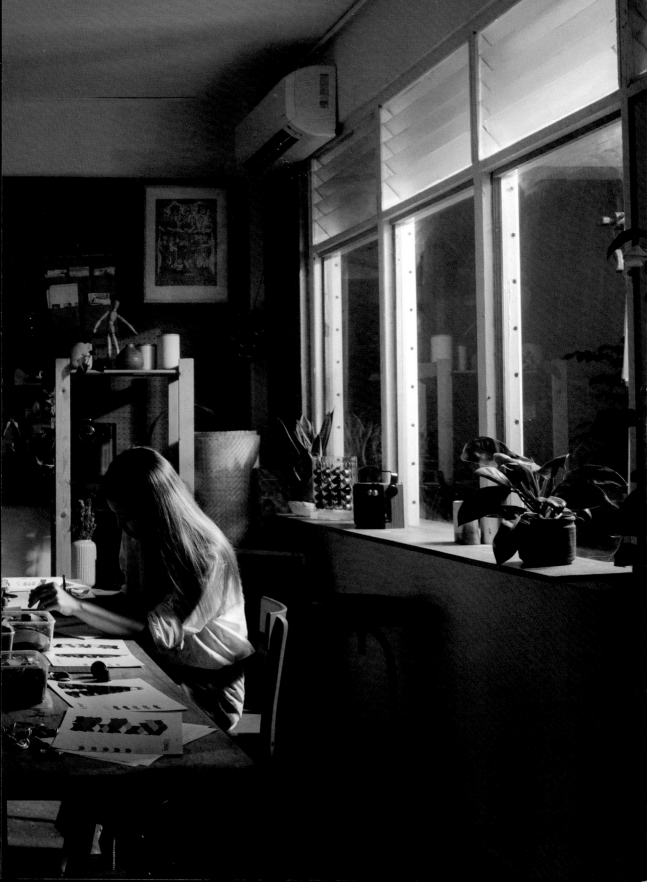

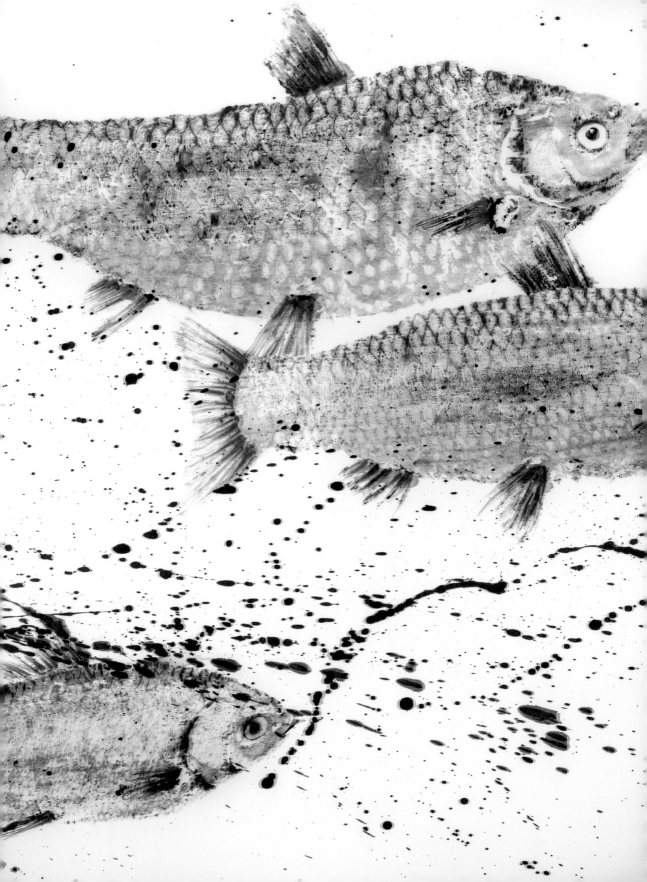

To my mum and dad,
* who first taught me how to paint*

HOW TO PAINT WITHOUT A BRUSH

THE ART OF RED HONG YI

ABRAMS, NEW YORK

CONTENTS

10 序言 PREFACE

34 材料 MATERIALS

2012

36 袜子 SOCKS

2015

46 茶包 TEA BAGS

2018

64 煤烟 SOOT

84 蛋壳 EGGSHELLS

2020

100 身体 BODY

110 蔬菜 VEGETABLES

2021

124	火柴	MATCHSTICKS
148	土壤	SOIL
172	刻铜	COPPER

204 Red's Do-It-Yourself Projects

208	煤烟	1. Painting with Soot
212	蔬菜	2. Vegetable Stamping
216	花与羽毛	3. Painting with Flower Petals
220	豆子	4. Painting with Beans
224	鱼拓	5. Fish Impressions
228	咖啡	6. Printing with Coffee
232	蛋壳	7. Eggshell Mosaic

| 236 | 感谢 | ACKNOWLEDGMENTS |

序言

xù yán

I see my art as a time capsule—a way for me to document events around me and to share these experiences, which I hope will travel across borders, people, and time.

PREFACE

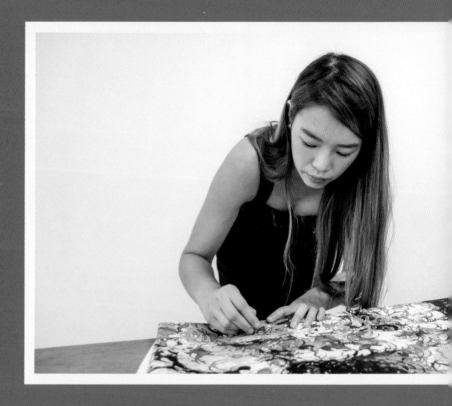
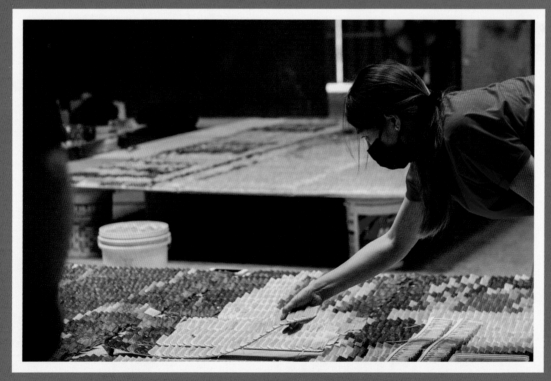

I remember being wide awake in bed the second I turned twenty-five. I was now entering my late twenties, and I felt so old. How silly of me, as I look back ten years later, but back then, that sense of dread was debilitating. I panicked as I thought about what I wanted to achieve in the next five years. All I'd ever wanted to do was to create art, yet I was too afraid, too embarrassed, and I felt somewhat delusional for even dreaming of becoming an artist. I also had nothing to show in my portfolio. The last painting I did was in high school as an exam submission. I also had a sketch I made when I had my first heartbreak at nineteen, but I was too humiliated to show it to anyone.

It was this sudden realization of time ticking by that forced me to plan a road map: I would move to a new country, make art informed by my new environment, and put it out in the world even if I thought my creations were awful. And then I would create some more and eventually organize a solo exhibition. I never went to an art school; I studied architecture. Architecture taught me how to plan, design, and construct structures to scale. This training made me more aware of the materials and textures around me. I would often touch or knock on an interesting object I came across, to study the material closer. This led me to exploring unconventional painting materials such as chocolate sauces, dried leaves, and paper cutouts. I would sometimes leave these objects on streets as a form of guerrilla art, and hide nearby to observe how passersby would engage with them.

To me, art is about self-expression, while architecture is about problem-solving. I yearned for that freedom of expression and communication in art, and I was determined to work on it as I entered my late twenties.

In April 2011, I moved from Melbourne to Shanghai, where I worked as a graduate architect, because I wanted to connect with my roots and experience the development of the biggest country in the world.

Living in China opened my eyes. I immediately realized that I had many preconceptions about the country that were skewed by the media and my own ignorance. I was fascinated by the mix of old traditions and newly built environments and found the speed of development and change in such a populated city both dizzying and exciting. The country has its own problems, but its convenience, public transportation, and safety were second to none.

China shocked me with its manufacturing power. I could easily purchase items in bulk at sample markets, at factories, and on e-commerce websites, and the affordable prices allowed for much more experimentation than when I was living in Malaysia or Australia. I didn't realize it at the time, but today, as I reflect on this, my practice was an appreciation of readymades—to borrow Marcel Duchamp's term—in which an artist appropriates and elevates found everyday objects in their art, ultimately using the work as a way to critique environments and cultural systems.

I also found deep respect and appreciation for this part of my own heritage and culture, and for the people: There was an entrepreneurial can-do spirit in the air. Many of the locals I met were hardworking, family-oriented, and creative in their own ways. I felt like both an insider and outsider while I lived there: I looked Chinese, but the moment I spoke, locals would say, "Oh, you are an overseas Chinese!" At times, I felt like a bridge: I could communicate fluently with both locals and foreigners. This was evident especially at my workplace, an international firm—sometimes I would be the messenger or translator between local and foreign colleagues. During lunch, I was always caught in between: Do I want to join my Chinese colleagues for Chinese food and catch up in Mandarin, or should I join the expats for sandwiches and talk about cross-cultural experiences in English today?

This experience of being an in-betweener inspired me to work on the project that launched my art career. In January 2012, I uploaded a video to YouTube of myself painting retired NBA star Yao Ming. My Chinese colleagues were discussing Yao Ming—his significance to the country and their guesses about his next ventures—and I wanted to share this excitement about a celebrated Chinese personality with my friends in Australia and Malaysia. I made the painting using a basketball dipped in red paint. Within days, the video went viral, with major news websites and TV networks featuring it. I continued creating my next few portraits with non-paint materials such as socks, sunflower seeds, coffee cup rings, and chopsticks, and just like that, I became an artist who paints without a paintbrush.

1
A vendor selling furniture in Shanghai.
I had never seen chairs stacked this way before.

2
Laundry hanging off bamboo poles overhead in a laneway in Shanghai. To me, it looked like an open-air exhibition by the residents in the area.

3
Bundles of chopsticks sourced from factories that were packed and shipped for an installation.

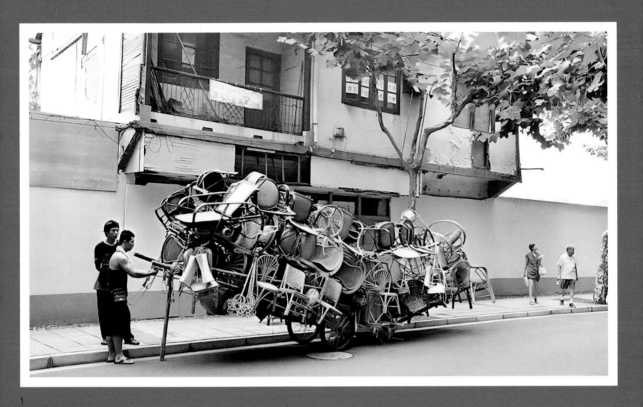

1

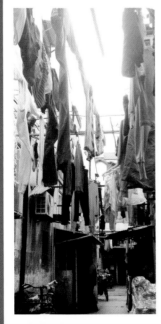

2

3

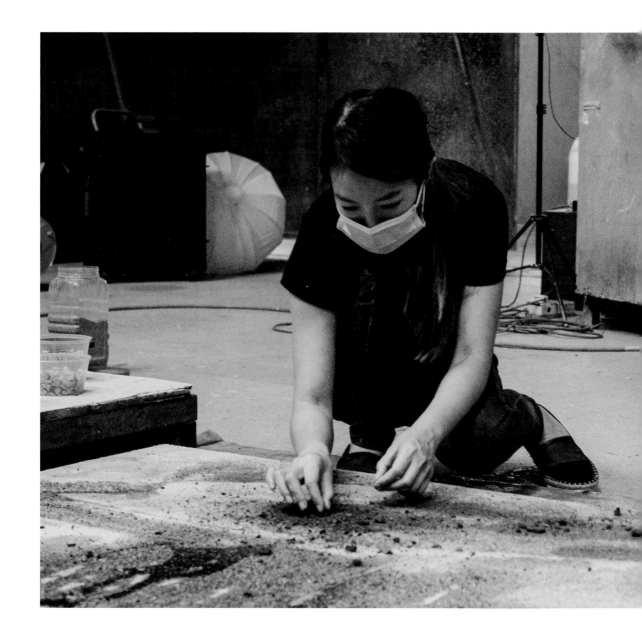

My time in China made me reflect on my identity as a Chinese Malaysian. It made me yearn to learn more about my family and my Chinese roots and to understand how I came to be Malaysian. For the first time, it inspired me to create art centered on the ideas of memory, portraits, and history that would raise questions about what it means to belong to two cultures simultaneously and highlight the diaspora of Chinese people all over the world.

For my art, I often work from photographs that are rendered with objects or materials, creating interpretations of my experiences. Perhaps I approach art this way because of my background in architecture: Photographs are my blueprints; objects are my bricks, concrete, and steel bars. The absence of a brush—a tool I am familiar with—forces me to both reimagine the way an object can be used and look at objects around me from a different perspective. It allows me to express my art in a personal way that feels natural and intrinsic to me by planning, calculating, building, and experimenting with scale and texture.

Inside this book, you'll find selected "brushless artworks" from 2012 to 2021, my first decade as an artist. I hope this book makes you realize that you can use anything to express your creativity and ideas. I have also included seven do-it-yourself projects at the end of the book to guide you through creating artworks with unconventional tools. So grab those chopsticks, tea bags, your stinky pair of socks, or even just your naked self. Tell your story through your lens on the world.

Here's to making art—brush or no brush.

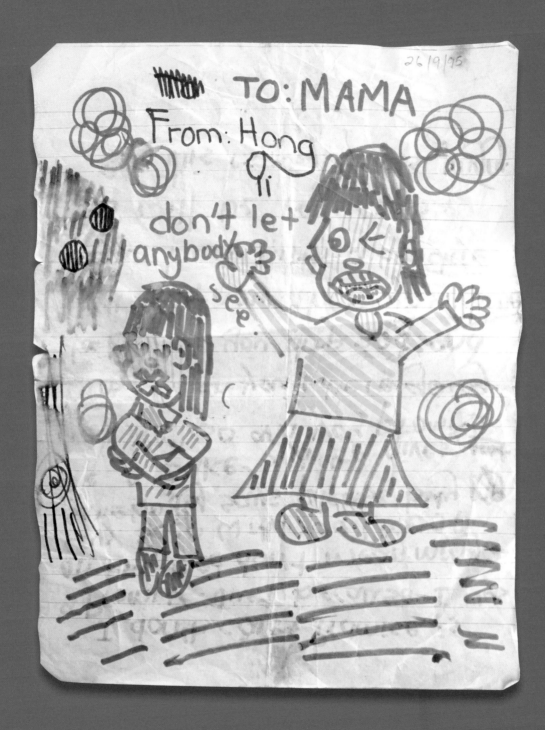

BACKGROUND

So you can understand my work better, I would like to share a bit about my background, my early influences, and what prompted me to become an artist in the first place.

I was born in the beautiful city of Kota Kinabalu, the capital of the state of Sabah, Malaysia. The city is also part of the island of Borneo. My parents are both ethnically Chinese; Chinese Malaysians make up about 23 percent of the country's population. My mother was born in Malaysia, and my father moved there from China when he was twelve years old. Growing up, my parents made the effort to stay in touch with our relatives in Shanghai and Guangzhou.

Even though I was always interested in art, I never considered studying it at university because it did not appear to be a secure career path. That was clearly drummed into me by well-meaning family and friends. However, my parents were always supportive of my interest in art. I remember both of them encouraging me as a child to paint and draw.

My mother enrolled me in art classes to develop painting skills. I first learned about Pablo Picasso through her when I was five. She had a Picasso print from IKEA in her room; it was a painting with just a single line depicting a woman. "How wonderful that Picasso could express himself with just a simple black line!" she told me. Oh, and I loved that thick Norman Rockwell book that she would show me every now and then. I admired how expressive his illustrations were and how he reflected everyday American culture in such a humorous, heartwarming way.

My father, on the other hand, is a technical person. He taught me how to sketch with different tools. When I was seven, he showed me how to color with Magic Markers, and then entered me into art competitions. I won one of them, out of a sea of three hundred kids. With that boost in confidence, I entered myself in another art competition, where kids were asked to draw their favorite animal. I was certain that my drawing of an Easter bunny would win. When the results were announced, I was surprised to not even get an honorable mention. With a hurt ego, I approached one of the judges to ask why my art did not impress them. I was probably eight at the time. His response? "Your art did not make me feel. You can draw, but your bunny looks like something I have seen before on a birthday card." His words are still relevant to me today. "See the drawing of that shark over there?" He pointed at a wildly unrecognizable drawing of a shark, on paper almost torn from aggressive pencil marks. "I can tell that kid likes sharks."

As a kid, I was also interested in science, specifically physics and math. Perhaps my father, who is a structural engineer, influenced this. He would show me science experiments, such as displacing liquids in vessels of different volumes or rubbing rulers on wool garments to demonstrate static electricity. So when it came to choosing a discipline at university, my parents and I decided that my combined interest in art, science, and math should lead me toward a degree in architecture.

Opposite: My mum kept many of the childhood doodles I gave her. Growing up, I was more comfortable expressing myself visually. This is one example of it.

In 2010, after six years in school, I graduated from the University of Melbourne with a master's in architecture. I remember the worry that followed immediately after graduating. What now? The Australian economy was at a lull and jobs were scarce, so I applied internationally to more than two hundred companies. Of the handful of architecture firms that replied, most of them were based in China due to the country's construction boom at the time. I accepted a position with the Australian architecture firm Hassell in Shanghai, but I hatched a secret plan to get transferred to their Melbourne office as soon as I could. Little did I know how much Shanghai would capture my heart. I fell in love with the city. It gave me the rare opportunity to connect with my roots.

I remember the flurry of excitement when I accepted that graduate architect position in Shanghai. My family members in Malaysia started calling our relatives in mainland China. "Yi is moving to Shanghai! Can she live with you?"

I lived in Shanghai with my eighty-plus-year-old grand-aunties and grand-uncles in an old shikumen (石古门) house, a traditional residence that combines Chinese and Western architectural styles. Those were some of the best times of my life. My grand-uncle showed me how to hang laundry by balancing a bamboo pole on our windowsill. My grand-auntie brought me to wet markets to buy the best hairy crabs. We danced in my grand-auntie's living room to old Chinese songs. We'd watch Chinese reality shows after dinner. Their favorite one was a Chinese matchmaking game show; it was amusing to hear them bicker and debate over who would or wouldn't make a good partner.

One morning, my grand-auntie came up to me with some life advice. She said, "I noticed that you don't make your bed in the morning! It just takes five minutes of your time, and it sets the whole day right!" I've been making my bed every morning since then.

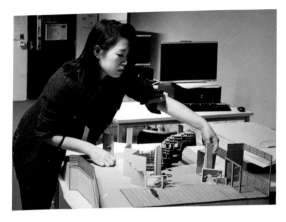

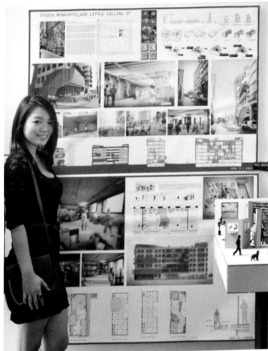

A photo of me with my graduate project: a building consisting of artist studios and gallery spaces.

There were some nights when I would be out late with my colleagues, partying in the city. The next day, I would hear my grand-auntie gossiping over the phone. "She came back so late! I wonder who she was out with?"

After a few months, as we got closer, I asked them more personal questions that I was eager to find out about: "What was it like living in China all of your life? What was your childhood like? What was my father like as a child? How do you feel about China progressing so much today?" Life was so different, so exciting. I was experiencing the rapid growth of the city and country while also learning about my family, their perspectives, and my heritage.

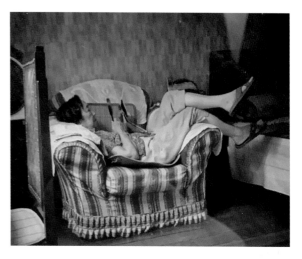

My sassy grand-auntie lounging in her room.

Life was so different, so exciting. I was experiencing the rapid growth of the city and country while also learning about my family, their perspectives, and my heritage.

The view from my room, in my grand-auntie's shikumen house in Puxi, Shanghai.

Photos of propaganda paintings by my grand-uncle that were created during the Cultural Revolution.

My grandma's older brother, whom I endearingly called San Gong Gong, or Third Grand-Uncle, was a full-time artist from the 1950s through to the 1970s. He was trained as an oil painter and painted many picturesque Impressionist landscapes of the Chinese countryside. However, he later had to switch his painting methods to a distinctive illustrative style for propaganda posters that were produced in the 1950s and 1960s. We shared a special bond. Every time I went over to his house we would talk about art for hours, and he would show me precious paintings that he still kept with him. He emphasized the importance of art and of expressing oneself through individuality. He passed in 2020 when COVID-19 was raging throughout the world. I could not fly back to China to see him. I wish I had documented his story more, but as I reflect on his life and career, it inspires me to continue to make art and to tell his story and the stories of my family, heritage, and roots.

I started my position as a graduate architect in May 2011. I was designing buildings on weekdays, but I tinkered with art projects during the weekends. I wandered through sample markets in Shanghai, and even took a train to Yiwu, the sample market capital of the world, to source materials for my art.

San Gong Gong showed me the few original paintings
he had left, including this one of his daughter preparing
for TOEFL exams in his longtang house in Shanghai.

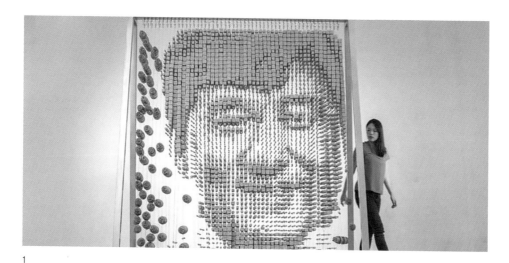

1

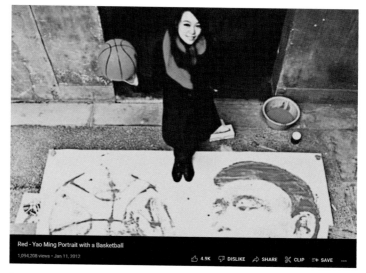

2

Red - Yao Ming Portrait with a Basketball

1,094,208 views • Jan 11, 2012

👍 4.9K 👎 DISLIKE ↪ SHARE ✂ CLIP ≡+ SAVE ...

3

I began a personal project in 2012, a series of portraits featuring Chinese personalities popular in the Chinese media. I selected photographs of Yao Ming, Jay Chou, Zhang Yimou, and Jackie Chan and re-created them with unexpected everyday objects that had an association with each person. I took photographs and videos of my process, showing how the portraits were made, and then shared them online with my family and friends.

My online following grew, and requests for commissioned works started coming in. While this was exciting, I remember feeling scared and confused because I had no idea what a career in art looked like in my generation. I wondered if I was delusional for even considering art as a career option, and if all these requests to create art would just vanish one day, especially in the age of quick consumable content on social media. And really, I was not even sure that I was creating "real" art. I kept questioning if my art was too amateur, too kitsch, too shallow. I created these artworks for my own entertainment, after all; I did not expect anyone outside my circle of family and friends to really pay attention to them.

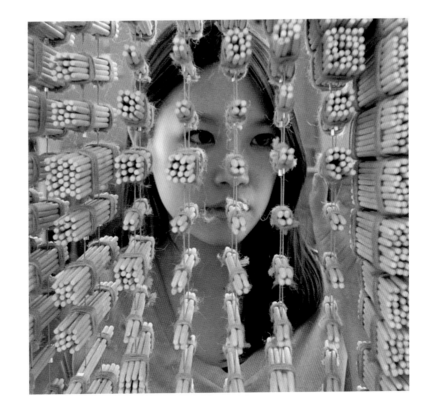

1
Portrait of Jackie Chan, created with bundled bamboo chopsticks.

2
Portrait of Jay Chou, painted with coffee-cup stains.

3
Portrait of Yao Ming, painted with a basketball dipped in red paint.

My boss at Hassell, Peter Duncan, was aware of my side projects and was supportive of them throughout my time with the firm. In fact, he was the person who gave me the push and safety net to give a full-time art career a try. When I expressed anxiety about the income, he told me that if the art thing did not work out in six months' time, I could return to working at the company. I had no excuse not to give it a go.

I met Aggie at Hassell, and she became a close friend. When I first went into art full-time, she helped project-manage many of my earlier artworks. I definitely needed help with contracts written entirely in Mandarin!

Creating an installation of tea bags in a rented warehouse space in Melbourne.

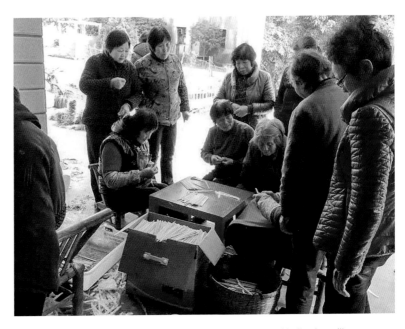

I spent two weeks tying bamboo chopsticks with a group of ladies in a village in southern China for one of my artworks. This was one of the most memorable experiences I've had, and I wish I had taken more photos of this experience.

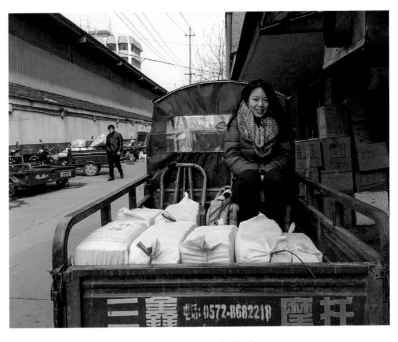

Sourcing bamboo chopsticks in a factory area in Zhejiang.

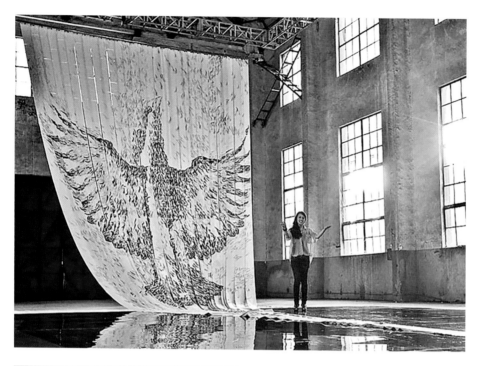

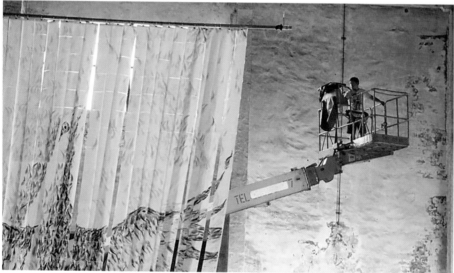

My first commissioned artwork was a three-story-high piece
created with feathers that were scanned then printed on
1,500 sheets of A4-size (8.3 × 11.7 inches/21 × 29.7 cm) paper
for Hewlett-Packard. This piece was created and installed in Shanghai.

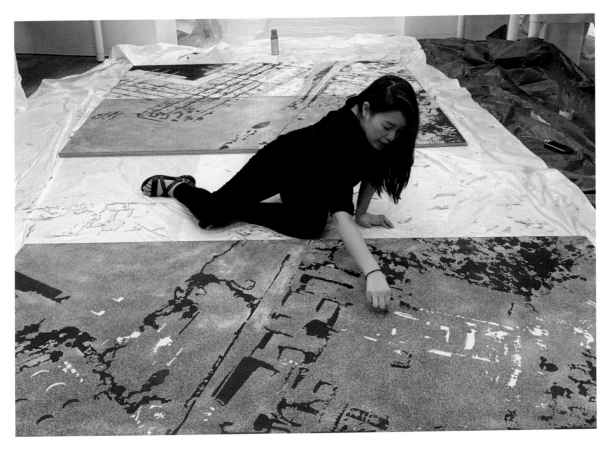

Creating artworks in a temporary space in Singapore.

I left Shanghai in mid-2014 and traveled frequently for commissioned art projects in various countries. Between 2014 and 2019, I lived out of my suitcase, spending most of my time between Australia, Singapore, Malaysia, and Los Angeles. During those years, I rented short-term studios and worked with freelance artists who assisted me with my art projects. I spent a lot of time traveling and enjoyed the freedom of not being bound to one place. However, I wish I had taken more photos of my artwork during this time. While compiling this book, I realized I did not have much documentation for my earlier work. I should have prioritized this much earlier, and now, more than ever, I am reminded that this is an essential part of every project. Beginning in 2020, I took documentation much more seriously by hiring photographers and videographers for each project and eventually investing in my own digital camera.

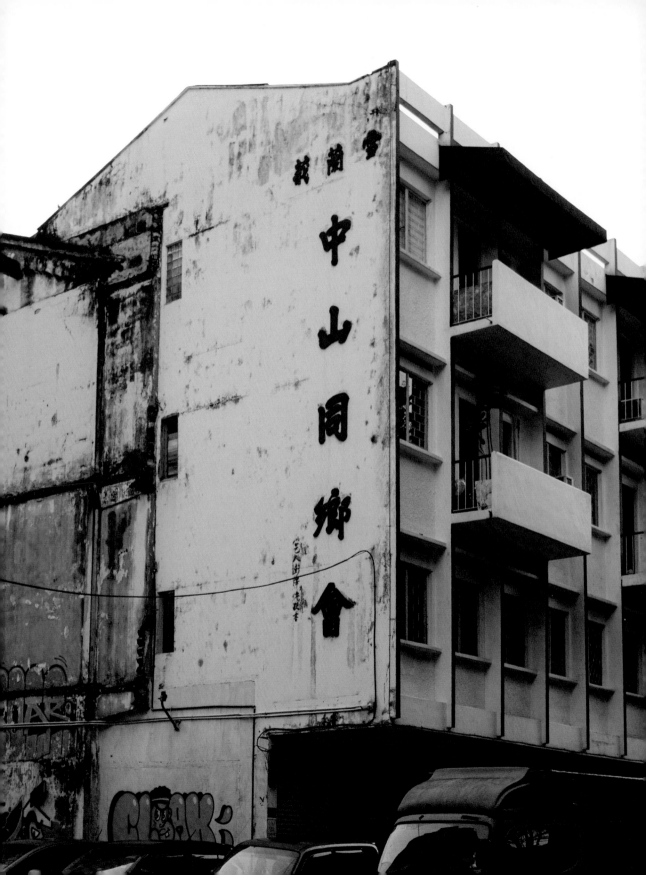

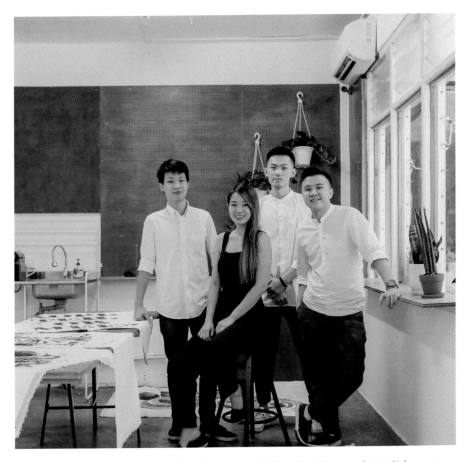

The first team after setting up a studio in Zhongshan Building, Kuala Lumpur (opposite), consisted of three architect graduates: Leong Chee Chung, Yan Wai Chun, and Wong Kai Yi.

That same year, when COVID-19 changed the world, I found myself stuck back in Malaysia. I was initially anxious about not being able to travel for projects, but being grounded in one spot turned out to be a good thing for my career. This period of isolation gave me the time and space to think about what I wanted my career to look like in the years ahead. I went deeper into my practice, spending time refining my ideas and goals and focusing on my art rather than responding to external influences. In hindsight, the constant traveling distracted me from creating better work. So with that realization, in July 2020, I rented a cozy studio in the Zhongshan Building, a creative hub in the city of Kuala Lumpur, and sent out a call for designers to join my practice. By the end of the year, I had assembled a team of four. In 2021, four more interns joined us, making us a team of nine. We also moved into a larger ground-floor studio in a nearby building called Sam Mansion Flat that has allowed us to work on larger installations while still keeping us close to the creative community.

My leap into art as a full-time career was a plunge into the unknown, as cliché as it sounds. But here I am ten years later, still an artist, and yes, still loving it. In hindsight, it was a mixture of courage and naivete that pushed me to create art even though I knew nothing about what it takes to be an artist.

As you flip through this book, it may be easy to assume that my productivity has been smooth-sailing, and that inspiration strikes me often. The truth is, there have been many moments of fear and doubt. In my earlier years, I often worried if my art was good or bad, and if people could tell that I was feeling lost. I wish I had someone to shake me then and tell me that I can do things differently, and that it is a strength to embed my own thoughts, ideas, and techniques into my artwork, even if they seemed bizarre or strange. My inspiration came from the rediscovery of everyday materials around me to tell stories of personal experiences, heritage, and culture.

I hope this book will be one that will encourage and inspire you to speak in your own unique voice, and to use tools and skills that you have at hand.

Anything can be art. See your surroundings with fresh eyes. You can use anything you have around you.

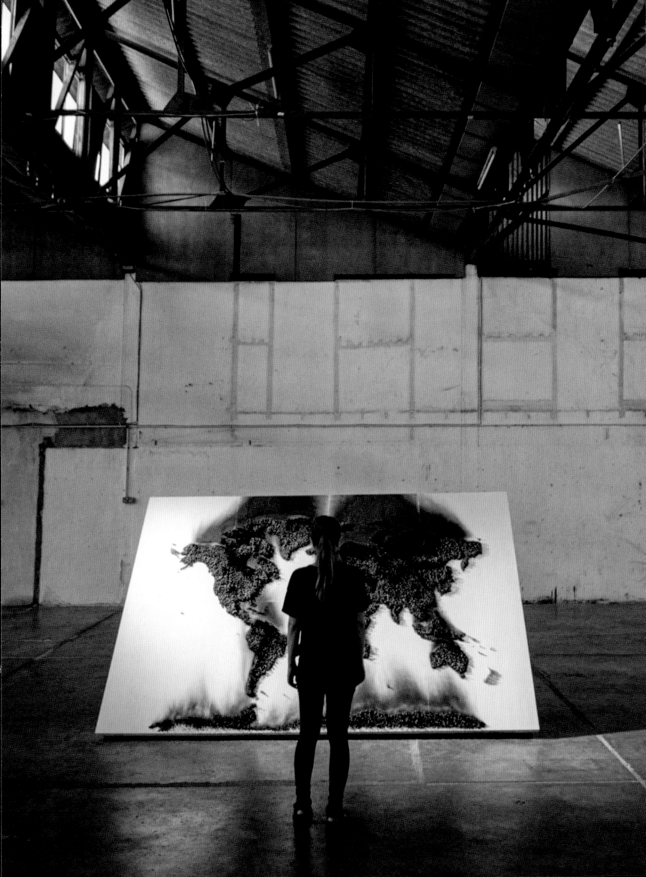

材料

cái liào

I hope this book makes you realize that you can use anything to express your creativity and ideas. So grab those chopsticks, tea bags, your stinky pair of socks, or even just your naked self. Tell your story through your lens on the world.

Here's to making art—brush or no brush.

MATERIALS

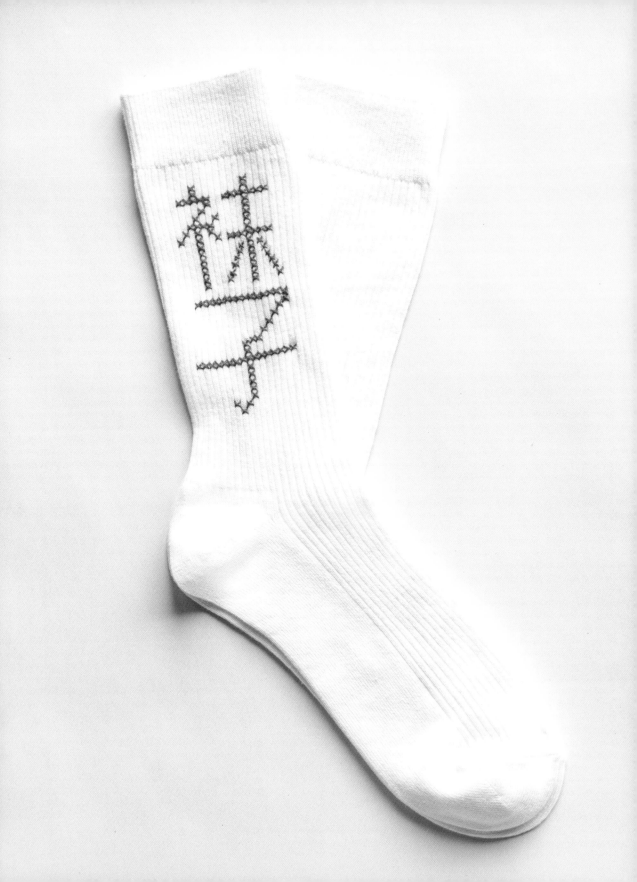

wà zǐ

SOCKS

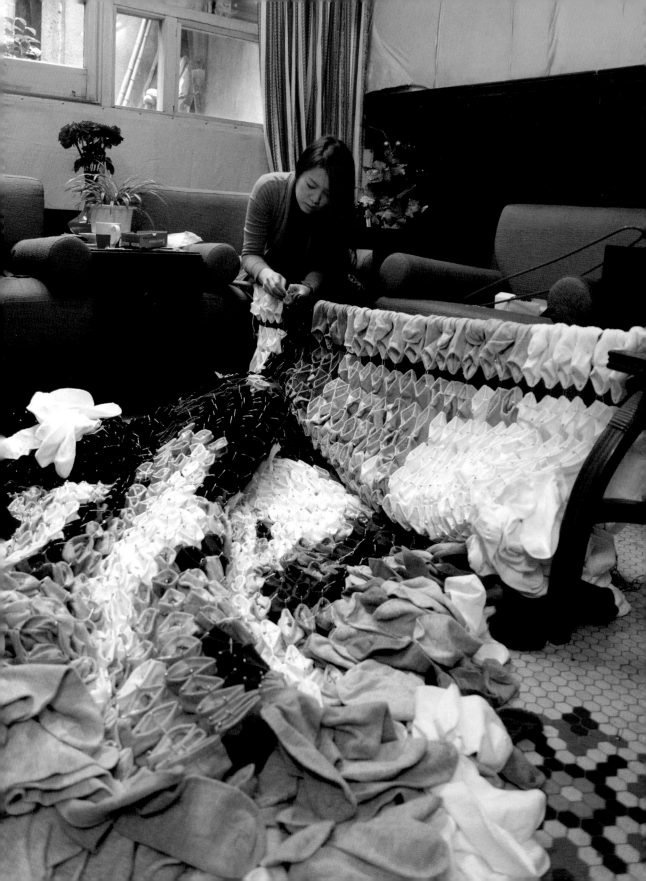

2012

When I moved to Shanghai in April 2011, instead of moving into an apartment downtown, I chose to live in a longtang (弄堂) with my grandparents' siblings. Longtangs are residential neighborhoods that date back more than one hundred years. They're located right smack in the center of Shanghai and are quickly disappearing to make way for urban development.

I loved living there. Longtangs are made up of mazes of lanes lined with row houses that are full of life. Imagine chattering neighbors, fruit and vegetable vendors, bicycles and motorbikes scooting in and out. Another defining feature of longtangs are the bamboo poles perched precariously across the lanes. These poles are suspended high above, from the windowsills of the row houses, with fresh laundry hanging off them. On sunny days, it felt as though residents were

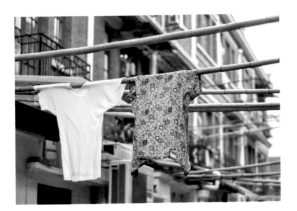

displaying a public exhibition of their clothing. You'd see colorful textiles—from jackets and blankets to bras and granny panties—wafting overhead. I loved it.

A portrait of Chinese filmmaker Zhang Yimou was my fourth project in a series of portraits I worked on. For this series, I wanted to create portraits of recognizable Chinese media personalities; I saw it as my way of personally introducing them to my friends and family living outside China.

I deeply admire and respect the films that Zhang Yimou has directed, and I love the way he tells stories about Chinese history and culture. I was particularly drawn to how, in his movies, bamboo elements are featured in various ways, whether in landscapes, as building materials, even as weapons and theatrical props. I also admired how he adorned his characters in beautiful Chinese costumes. It struck me that I could place his portrait in front of the old laneway house where I was living. I wanted to display an artwork in the same way that longtang residents hang laundry. The initial idea was to collect lots of T-shirts and hang them up with multiple bamboo poles, but I quickly discovered that this project was too ambitious and costly for me as a graduate architect. However, as I was sifting around a sample market, researching alternative materials, I realized that I had found exactly what I was looking for—socks! They were the smallest garments that I could find, and they fit within my budget. I ended up buying one thousand pairs in different shades. To make the portrait, I imagined that each sock was an individual pixel, and found a way to transform them, by pinning the opening of the socks at four corners to create a diamond-shaped unit.

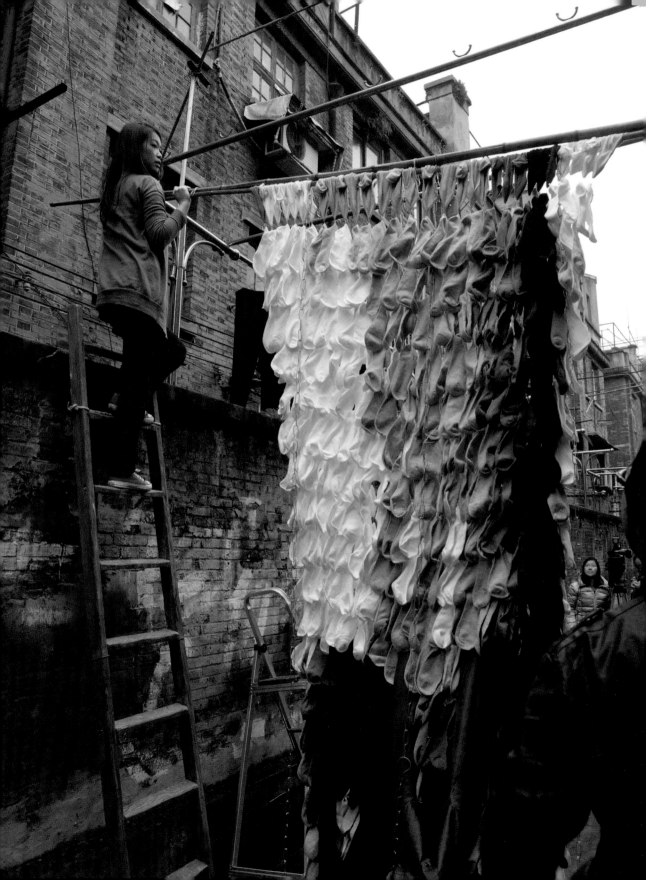

My first attempt at hanging the sock portrait failed. I didn't account for the weight of the socks, and the installation sagged so much that the portrait was overly elongated and unidentifiable. I had to go back to the drawing board. My father, who is a structural engineer, had seen my drawings weeks before and warned me about the weight of the piece, and suggested that I weave wire mesh into the portrait to distribute the weight of the socks, but I found his proposed solution to be too unsightly. However, after my first failed attempt, I decided to listen to his advice and bought rolls of wire mesh. I suppose that's why architects need engineers!

My father sent me the sketches on this page via WhatsApp. One of the solutions was to use chains and strings, but I opted for the wire mesh version.

Sock Data

2,000	socks
6,000	safety pins
1	bamboo pole
2	months spent pinning socks with safety pins

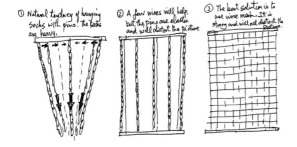

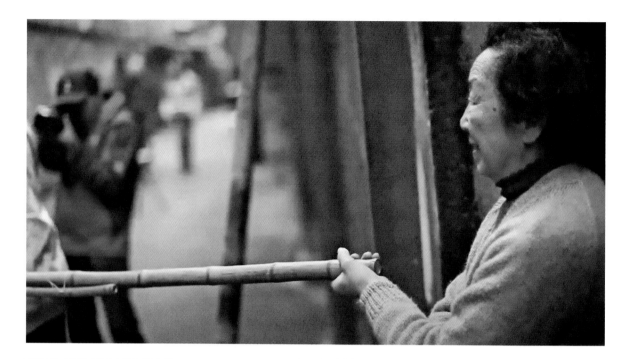

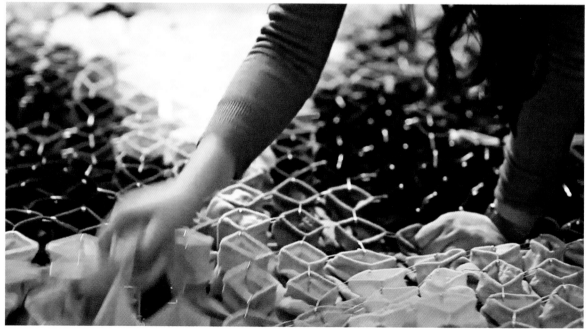

The three-minute-long video I worked on with Jonathon Lim
highlights life in longtangs and features a time-lapse of the
installation of this artwork. These are outtakes from the video.

After days of working, the time came to hang up the completed artwork. A couple of my work colleagues came over to help move the pinned socks into a laneway in front of my house. I also enlisted the help of my dear friend Jonathon Lim, an Australian filmmaker based in Shanghai, to film in the background and document the installation process.

The installation took a full day and attracted curious onlookers. Some even ended up helping me install the artwork.

What started out as a solo project quickly became a community project with more than twenty people. Throughout the day, neighbors, colleagues, relatives, and passersby came over to observe what I was doing, and although I gave no clear reason why I was doing this (I probably said, "I love the way you hang your laundry here!"), all of a sudden, they were part of the project too. I actually got to know my neighbors through this work. The whole process

was chaotic and noisy: Everyone was telling me what to do and moving my installation around, but despite the chaos, I didn't mind. It was beautiful seeing the community so excited and voluntarily come together to be a part of this neighborhood-based project, one that had been inspired by a local way of life.

This will always be a memorable experience for me because it brought me closer to the local residents, letting me collaborate and discuss life and art with them. They shared stories about their life in China, and some talked about their own creative aspirations. One of the women in this photo brought me to her longtang house and showed me her art project of dozens of empty eggshells with faces painted on them.

I realized that art is not just a solitary event, and it is not just for the elite; in fact, art can be experienced and enjoyed by a wider community, bringing together people from all walks of life, even if they may see life in different ways.

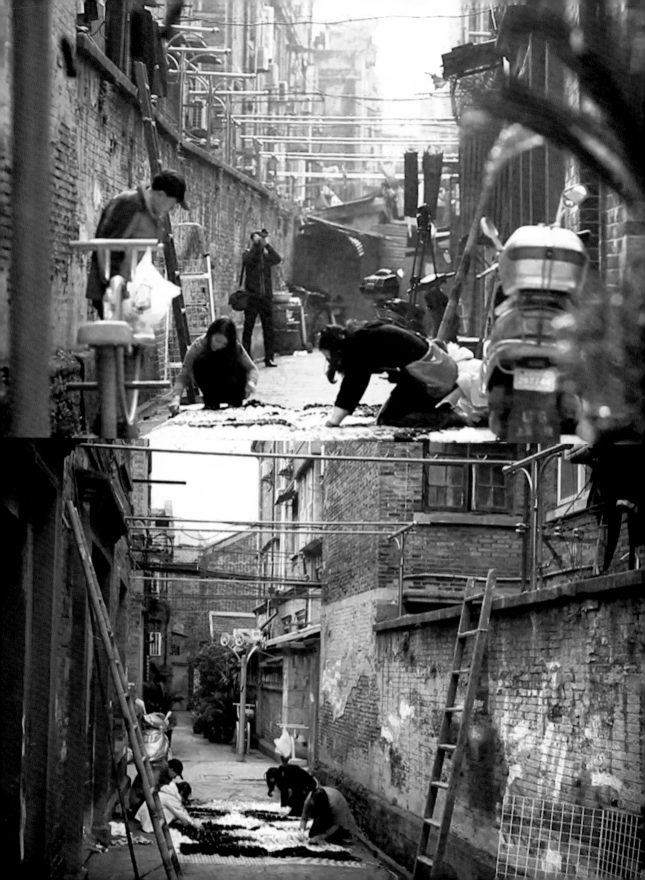

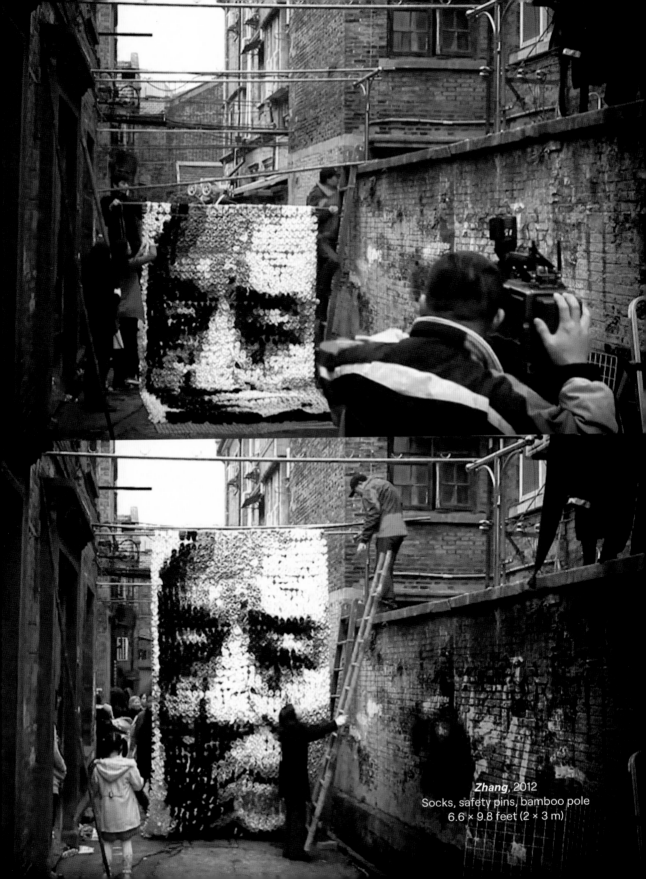

Zhang, 2012
Socks, safety pins, bamboo pole
6.6 × 9.8 feet (2 × 3 m)

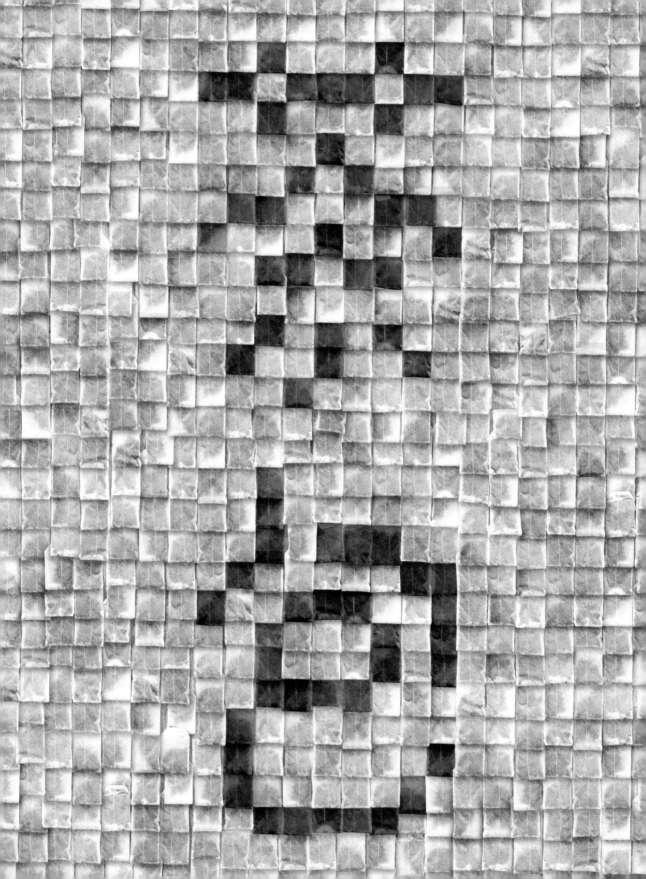

chá bāo

TEA BAGS

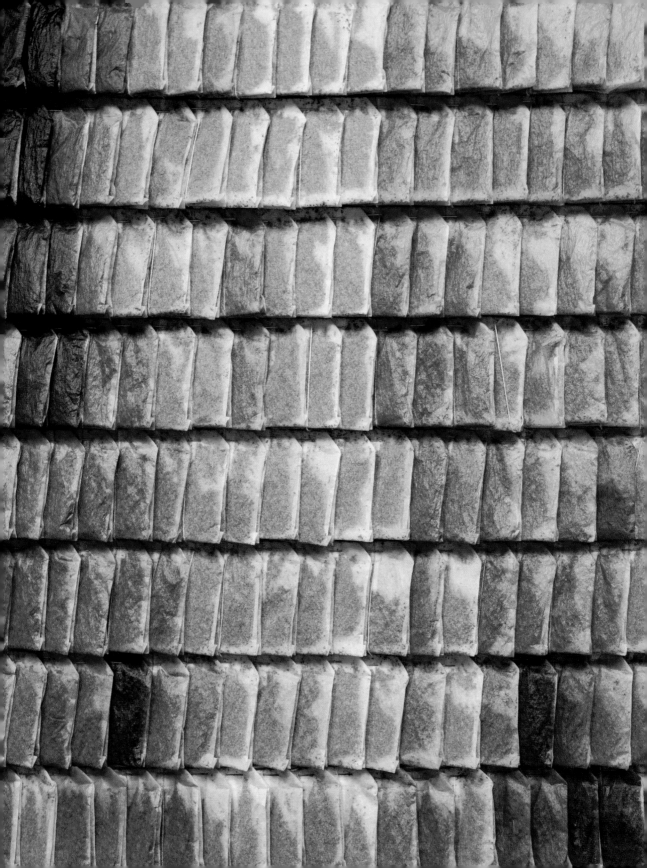

2015

In late 2014 and 2015, I created an artwork to be displayed at the World Economic Forum in Davos, Switzerland. It was important to create something that would allow people to experience an everyday scene in Malaysia. At the same time, I wanted the experience to be sensory, both visually as well as through the sense of smell.

At the time, I had just left China and moved back to Melbourne temporarily. The move made me wonder where home was. I suppose home will always be connected to my memories of childhood, and Malaysia will always still be home. When I think of Malaysia, I think of food. I taste and smell it first.

For this artwork, I wanted to physically create the flavors of food from home that I craved. One of those things is teh tarik, or "pulled tea," a frothy brew made by pouring—or pulling—streams of hot milk tea between two cups. I also wanted the piece to celebrate average hardworking Malaysian locals. Eventually I settled on the image of an Indian Malaysian street vendor making pulled tea, a scene I distinctly remembered from when I was living in Malaysia and enjoyed street food.

A typical Malaysian breakfast of teh tarik (pulled tea), kaya toast, and soft-boiled eggs.

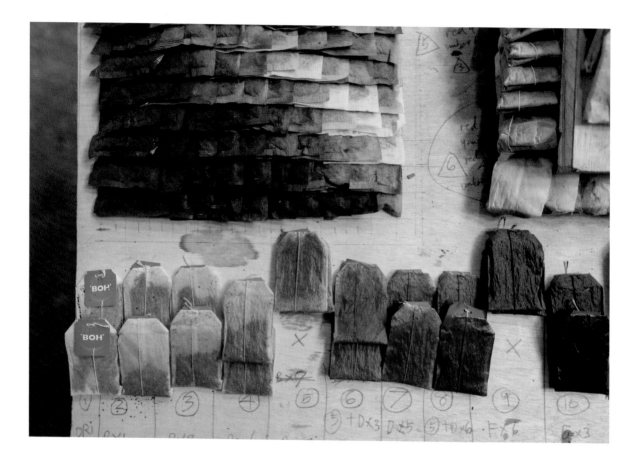

Because the subject was to be a person preparing pulled tea, I researched tea as a material and eventually chose to use tea bags for the work. I was drawn to them because of their resemblance to tiles that could be attached onto other objects with their strings.

I experimented with dyeing the tea bags with stains of different intensities, by soaking the bags in jars of tea of different brew strengths, adding acrylic paint into the concoction so the colors would last longer. The result was a fragrant red-brown stain that created a striking textural effect on the bags when they were dried up and wrinkled. I then used a pixelated image as a guide to affixing the tea bags onto my art piece.

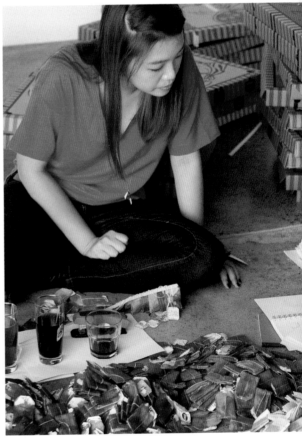

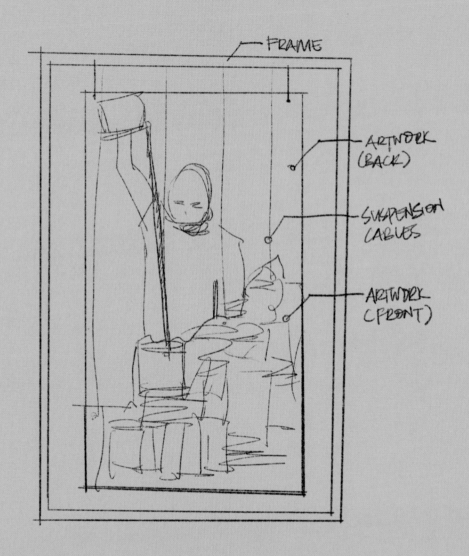

FRAME

ARTWORK
(BACK)

SUSPENSION
CABLES

ARTWORK
(FRONT)

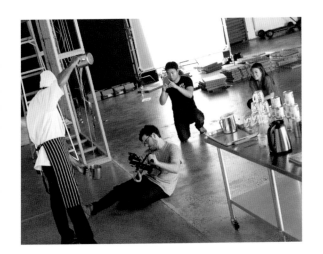

Tea Bag Data (2015)

20,000	tea bags
40	stainless steel mesh sheets, each 11.75 × 11.75 inches (30× 30 cm)
10	different tones of dyed tea bags
2	months dyeing and tying

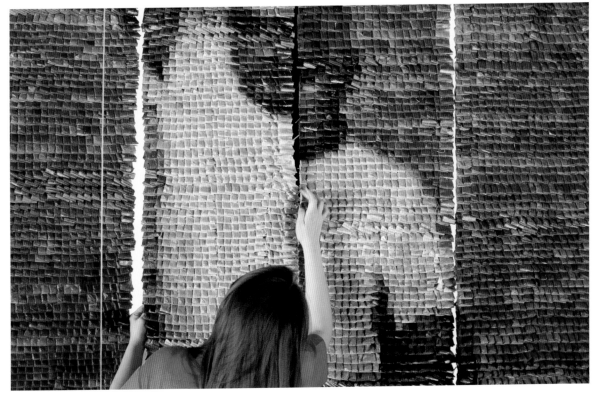

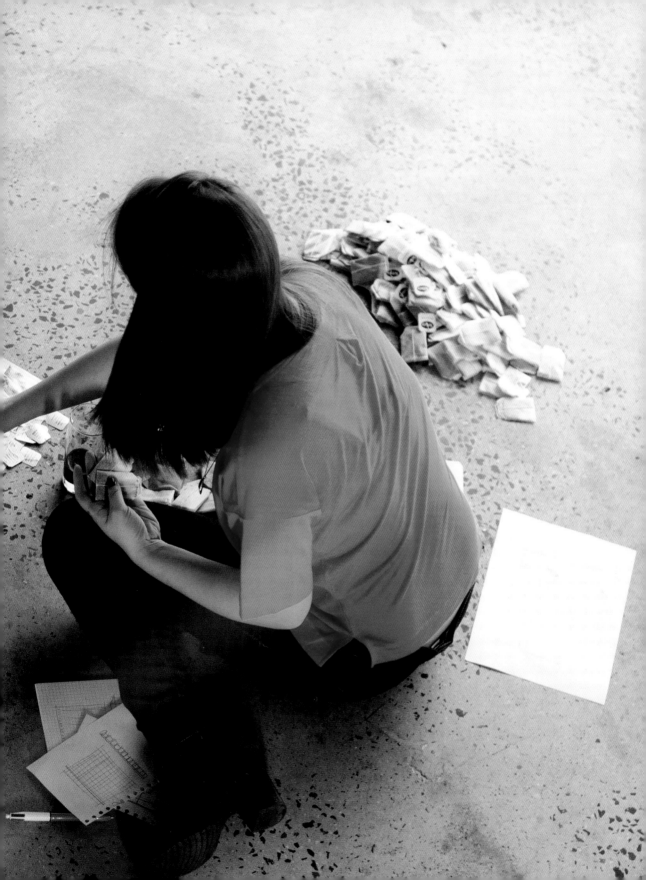

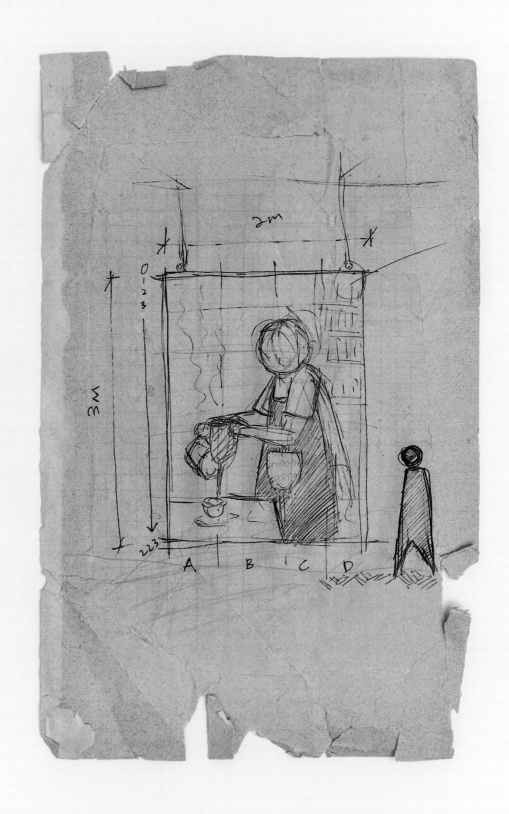

Five years later, I was approached to create another tea bag artwork for Resorts World Las Vegas. The client specifically requested an artwork that was inspired by street-food culture in Southeast Asia. This time, I created one that depicted a kopitiam owner preparing tea. Kopitiams are Chinese Malaysian–run coffee shops that sell affordable, no-frills local food and drinks. My team and I visited local kopitiams for our research and even befriended a few of the vendors. The bonds that were formed in the process of creating this artwork make it all the more meaningful for me.

The colors and objects that populate these works originate from my daily life in my Malaysia. These tea bag pieces awaken the senses with their smell and warm brown tones while also capturing an everyday scene familiar to all Malaysians as they start their day or take a morning break.

Tea Bag Data (2021)

18,500	tea bags
3	stainless steel mesh sheets, each 3.3 × 6.6 feet (1 × 2 m)
7	different tones of dyed tea bags
2	months dyeing and tying

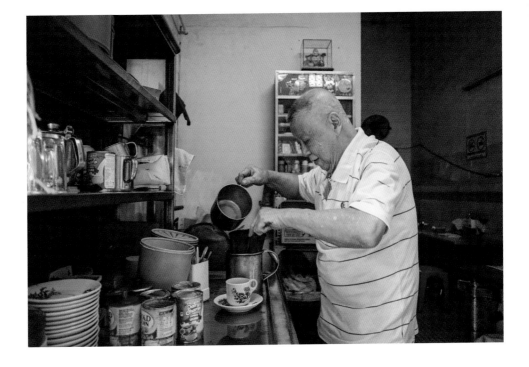

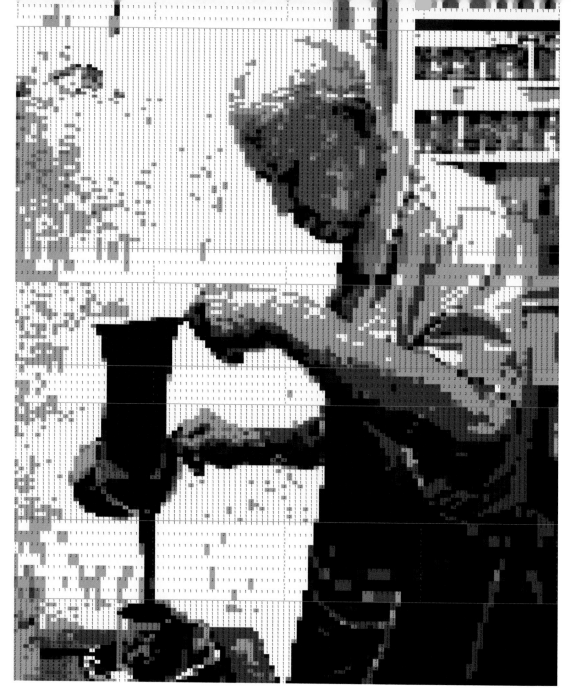

We collaged a few elements from the images that we took, then pixelated the image to what is shown above. Similarly, we categorized the image into seven different tones.

1 2 3 4 5 6 7

```
1 1 1 1 1 1 1 1 1 1 1 1 1 1
1 1 1 1 1 1 1 1 1 1 1 1 1 1
6 1 1 1 1 1 1 1 1 1 1 1 1 1
4 5 1 1 1 1 1 1 1 1 1 1 1 1
4 4 1 1 1 1 1 1 1 1 1 1 1 1
5 2 1 1 1 1 1 1 1 1 1 1 1 1
5 2 1 1 1 1 1 1 1 1 1 1 1 1
2 4 1 1 1 1 1 1 1 1 1 1 1 1
2 3 1 1 1 1 1 1 1 1 1 1 1 1
3 1 1 1 2 1 1 1 1 1 1 1 1 1
1 1 1 1 4 2 1 1 1 1 1 1 1 1
3 1 1 1 3 4 1 1 1 1 1 1 1 1
1 1 2 1 3 1 1 1 1 1 1 1 1 1
2 1 2 1 4 1 1 1 1 1 1 1 1 1
1 2 1 3 4 1 1 1 1 1 1 1 1 1
1 3 2 6 4 1 1 1 1 1 1 1 1 1
3 4 1 3 4 2 1 1 1 1 1 1 1 1
7 6 5 6 6 6 4 4 1 1 1 1 1 1
7 7 7 7 7 5 4 4 1 1 1 1 1 1
7 7 7 7 7 6 4 4 1 1 1 1 1 1
7 7 7 7 6 5 4 6 1 1 1 1 1 1
6 7 5 4 1 1 1 1 1 1 1 1 1 1
6 6 2 3 1 1 1 1 1 1 1 1 1 1
3 2 2 4 1 1 1 1 1 1 1 1 1 1
1 3 1 1 1 1 1 1 1 1 1 1 1 1
2 2 1 2 1 1 1 1 1 1 1 1 1 1
1 1 1 3 1 1 1 1 1 1 1 1 1 1
2 1 2 2 1 1 1 1 1 1 1 1 1 1
```

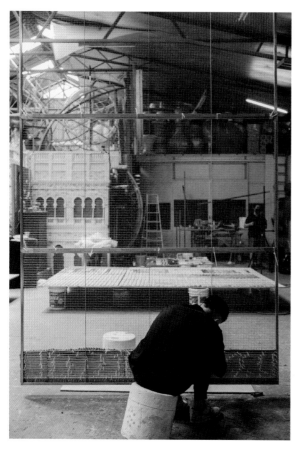

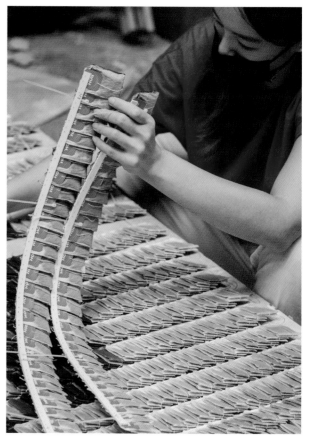

The structure of the artwork is formed from three wire-frames joined together to make a large portrait frame. Tea bags were first arranged into strips then tied to the wire frame layer by layer.

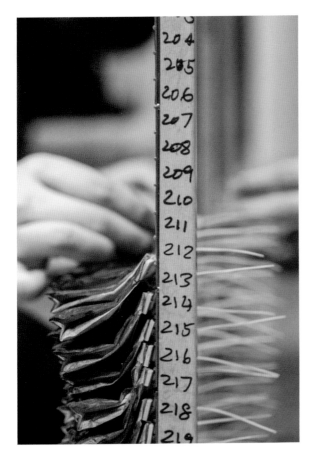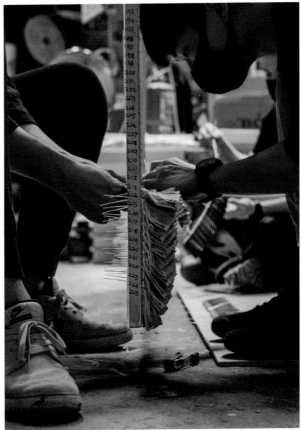

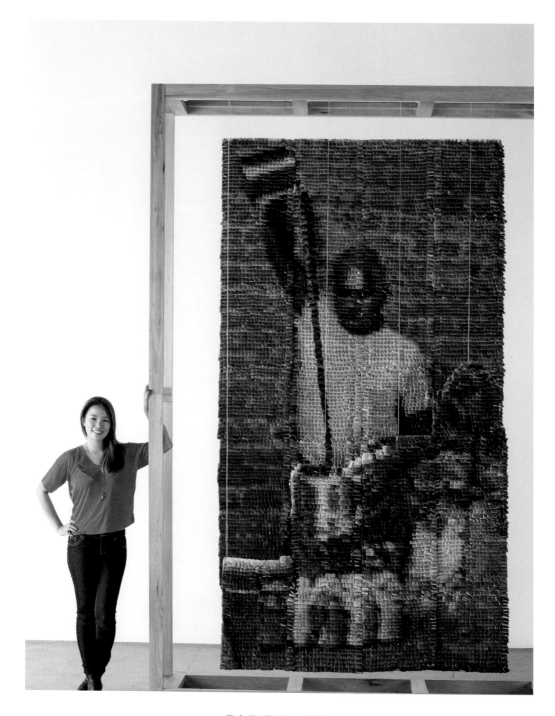

Teh Tarik Man, 2015
Tea bags, acrylic, stainless-steel wire mesh
4.9 × 9.8 feet (1.5 × 3 m)

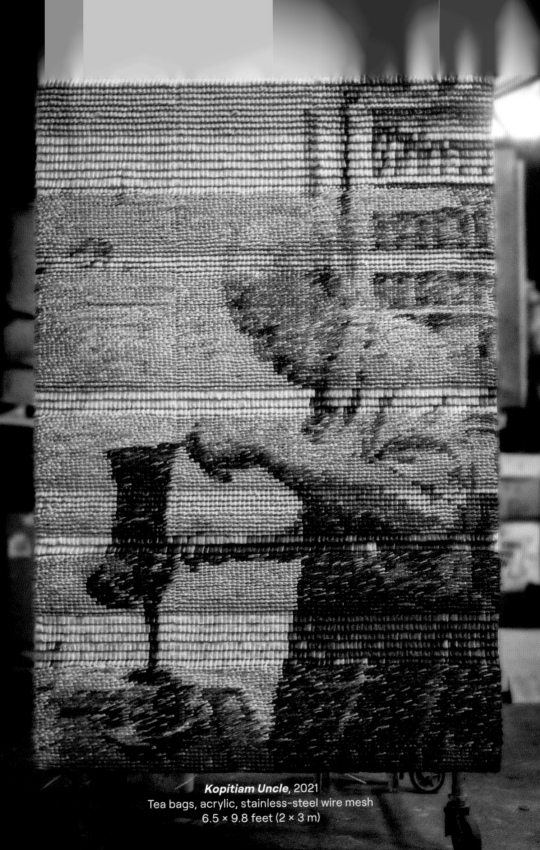

Kopitiam Uncle, 2021
Tea bags, acrylic, stainless-steel wire mesh
6.5 × 9.8 feet (2 × 3 m)

火暴

火田

méi yān

SOOT

2018

My work is often tedious and labor intensive because I think in units and pixels to render an image for my artworks: Imagine ten thousand little dots represented by an object—say, a tea bag—and the time that each tea bag will then take to tie, dye, and affix to the work. For a while, I had been looking for a medium that could be less rigid in terms of calculations and construction. Something that could still replace traditional mediums, such as paint, and be readily available so that sourcing it would not be overly challenging.

I came across soot as a material when I was experimenting with fire for a commissioned project. Its effect reminded me of diluted Chinese ink, but in a more forgiving way. I loved that I could just rub the soot off the surface anytime I was dissatisfied with the art I was making and start over again. However, as a material, soot was not particularly exciting or novel; after all, I could just as well use charcoal. Ultimately, this led to me exploring surfaces I might use the soot on.

I was back in my hometown of Kota Kinabalu when I was experimenting with this method. One day, I took a walk through the local market and saw woven bamboo mats for sale. That gave me an idea. I bought a few mats back for experimentation. With a candle, I applied the soot onto both treated and untreated bamboo and immediately saw the potential of bringing these materials together. By pushing and pulling the weaves, I was able to achieve a pixelated effect, almost like a QR code, and this resonated with my own approach of planning and calculating images to create "real-life" pixelations.

While working on this piece, I found out that the use of soot in art dates back to the twelfth century BCE, when charred materials were commonly used as decorative inks in early Chinese artifacts. Inksticks—a type of solid Chinese ink produced from soot and animal glue—are traditionally used in Chinese and East Asian calligraphy and brush paintings. I was also surprised to find out that soot was used as a decorative material for American furniture in the late eighteenth and nineteenth centuries. "Smoke painting" was a technique used to paint on surfaces of furniture to create a variety of patterns from waves to spots to dots. I do not claim to have discovered a new method or technique of creating art. On the contrary, I find it delightful learning how materials around us have been used by humans in generations past; it is fascinating reading about history and how humans have used materials from the world around us. I also love the challenge and creativity that come with making artworks from old materials with a contemporary twist.

I lived with my grand-aunties and grand-uncles for two years while working in Shanghai as a graduate. Their home holds many memories for me; though I did not grow up there, I feel a special bond and connection to it, as it was the same house my father and grandparents lived in before they left China. During a recent trip back to Shanghai, I created a smoke painting featuring

"I can recognize that this is your work. You need to keep at that. Work on your own style and voice. Don't dilute your own way of creating."

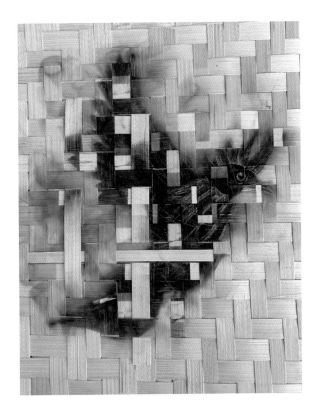

Early experiments with soot.

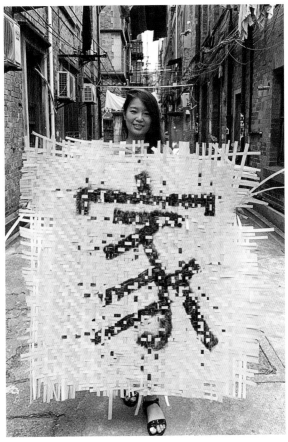

the Chinese character 家 that I displayed in front of my grand-aunties and grand-uncles' home. 家 (jia) means "home"; it felt natural and right to use the longtang facing their house as an open gallery for the residents. Shanghai, especially these old living quarters, will always be like home to me.

China has developed and advanced so quickly, but I hope they'll preserve some of these old quarters. These are the gems that make a megacity like Shanghai still so charming!

My grand-uncle gave me some advice when he saw the soot paintings I made. He said, "I can recognize that this is your work. You need to keep at that. Work on your own style and voice. Don't dilute your own way of creating."

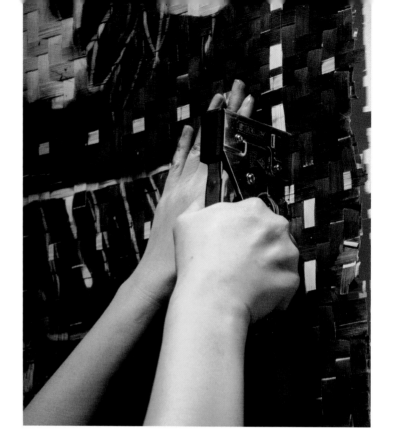

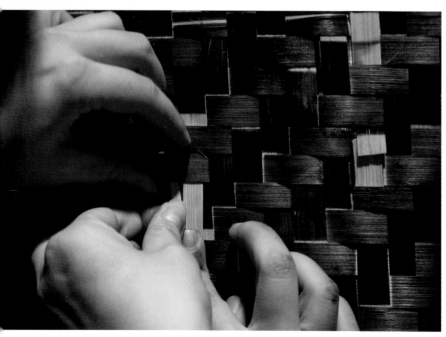

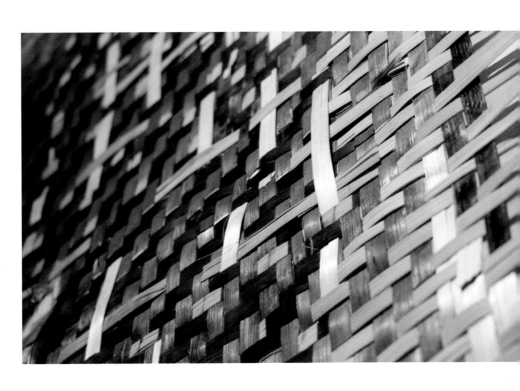

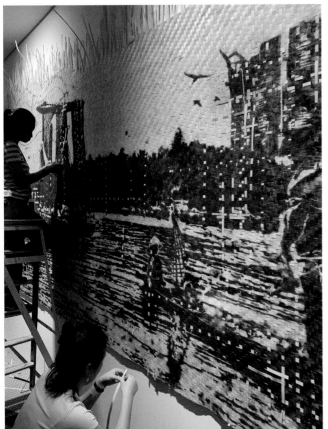

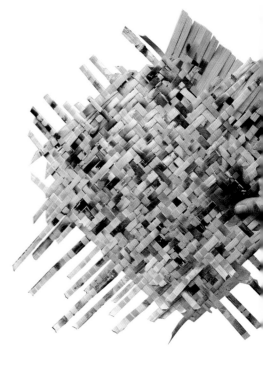

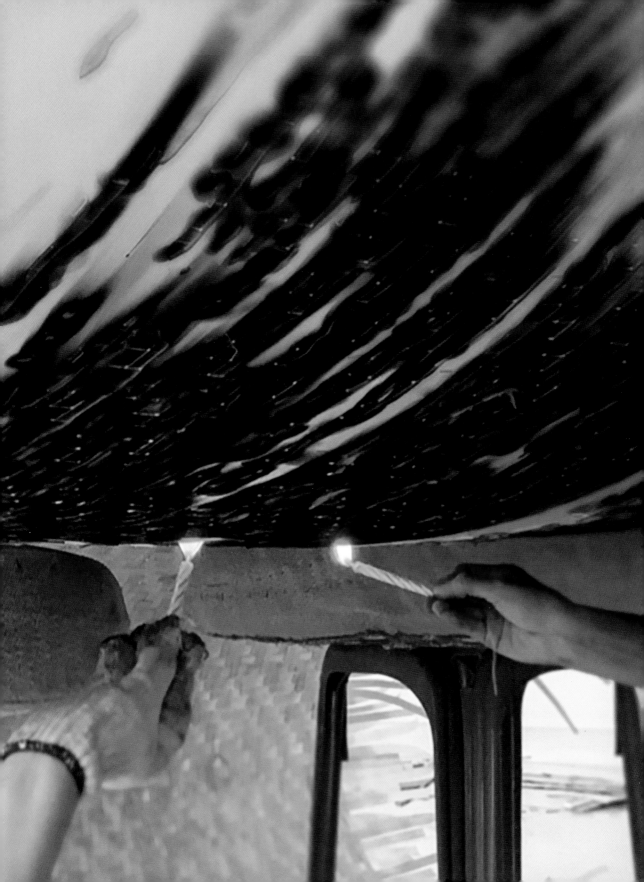

Soot Data

30	household dripless candles
32.8	feet (10 m) bamboo weaves
3	cans of spray fixatives
2	weeks sooting

In 2018 I was commissioned to create a 32.8-foot-long (10 m) artwork for an office in Singapore, so I revisited this technique. I sourced a bamboo mat of approximately the same length, spent weeks weaving the edges to the dimensions I wanted, and then spent another two weeks applying soot onto it with a team of four assistants. The treated surface prevented the soot from smudging easily, and once the painting was done, I applied layers of fixative spray to ensure the soot would stay in place.

My "sooting" process is similar to stenciling with spray cans. But before this process begins, a big part of my work happens on the computer. First, I spend time digitally manipulating photographs in Photoshop and Illustrator. Next, I export the images to a laser cutter for a cutout template, which I attach to the bamboo mat. Then, I move candles around beneath the mat to create the soot.

The charring effect offers a very dynamic, burnt, and even explosive appearance. There is also an element of surprise and unpredictability when using this material that I don't achieve with most of my other artworks, which are more planned and structured. There is a level of uncertainty and suspense as the intensity of the fire and soot, and the distance of the candle to the mat, crucially influence the final effect on the surface. These elements are not easy to control, and sometimes, the surface catches fire. When this happens, I tend to leave the charred areas bare and in their original state, instead of covering them up. I see this as all part of the art in using this technique.

The soot holds up surprisingly well on the mat. The uneven surface of the treated mat and the fixative spray make the artwork very durable.

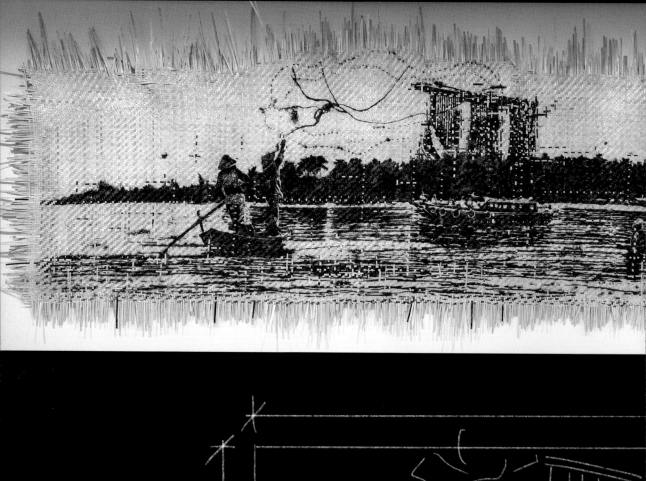

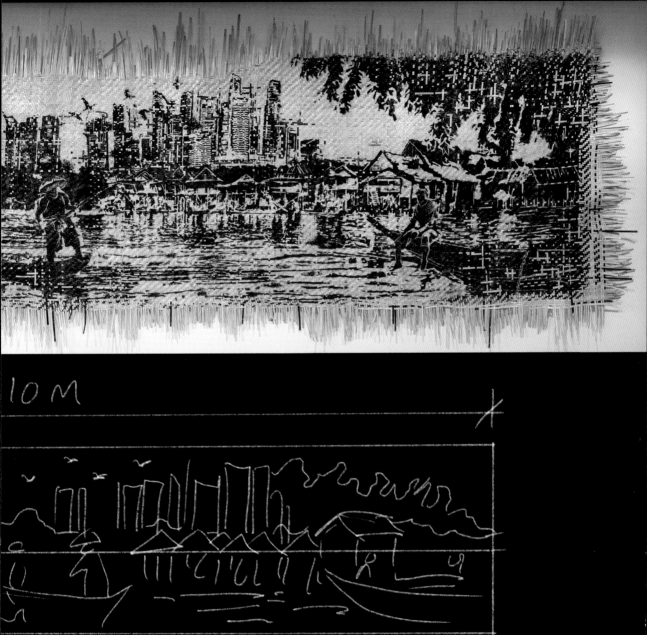

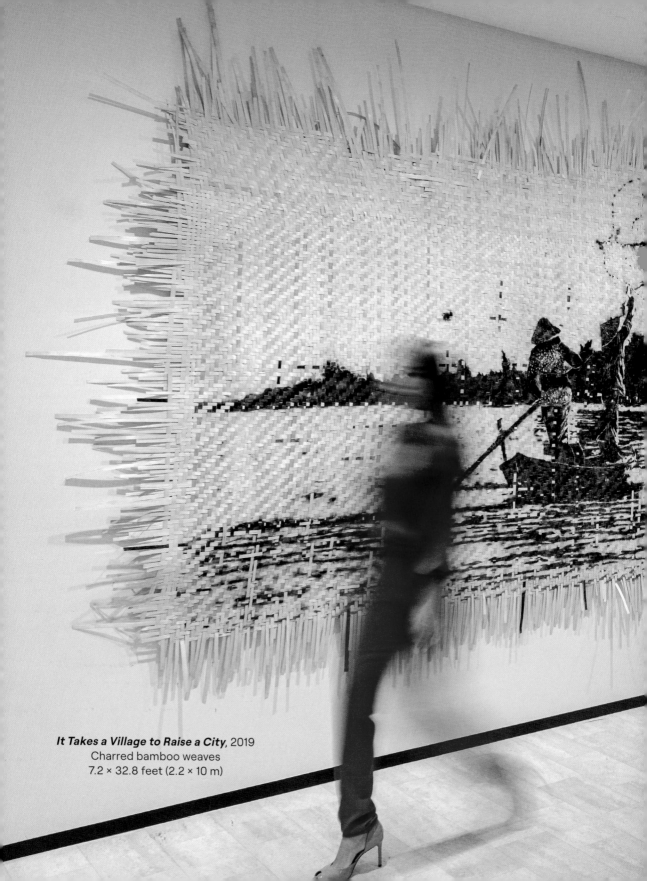

It Takes a Village to Raise a City, 2019
Charred bamboo weaves
7.2 × 32.8 feet (2.2 × 10 m)

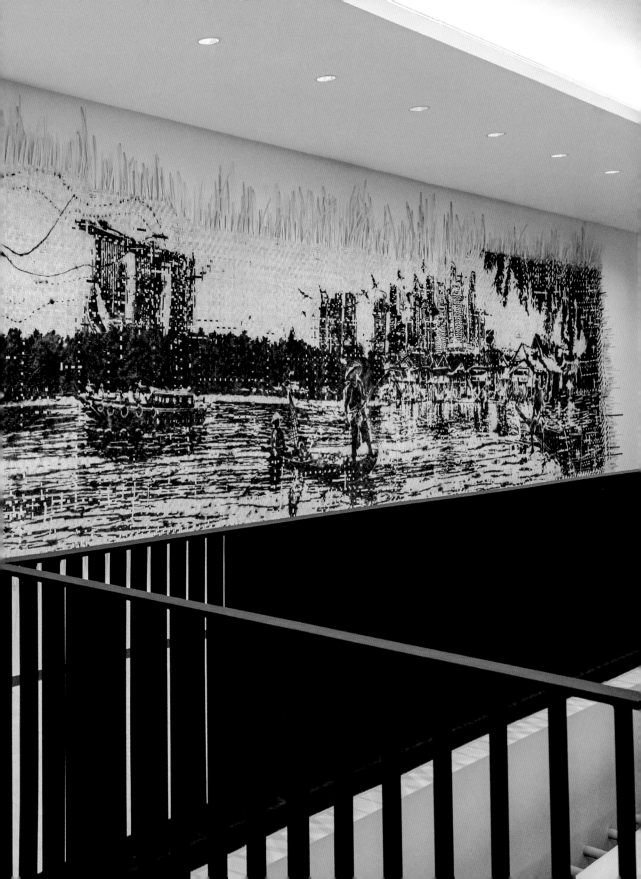

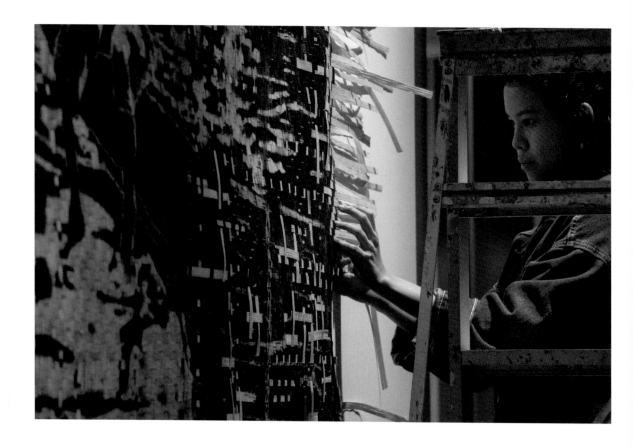

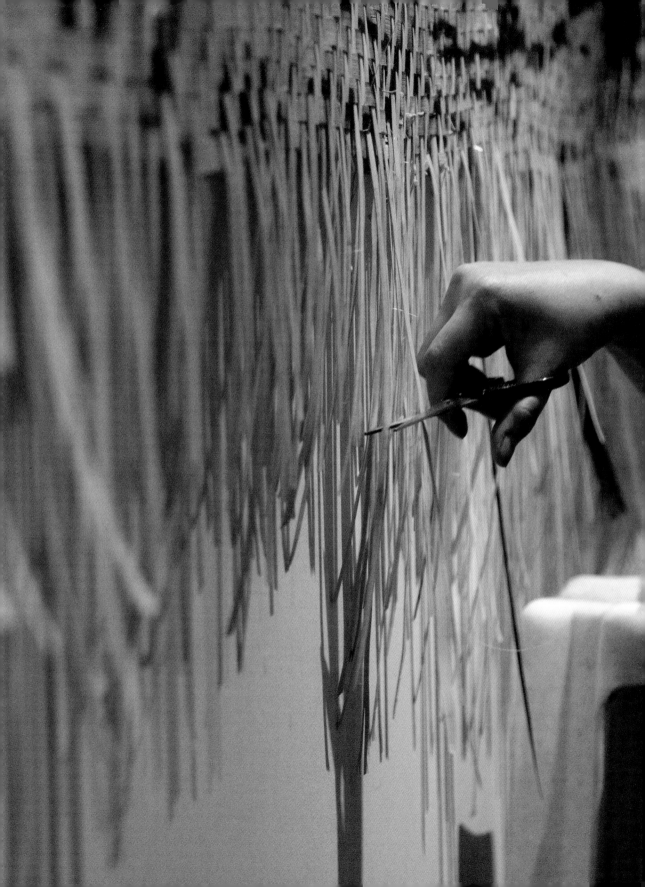

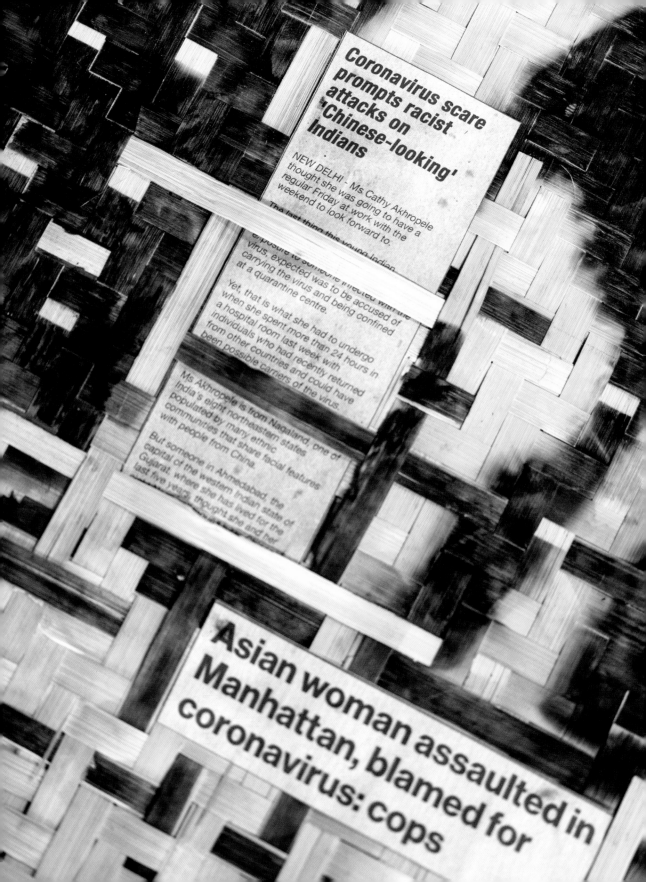

Coronavirus scare prompts racist attacks on 'Chinese-looking' Indians

NEW DELHI – Ms Cathy Akhropele thought she was going to have a regular Friday at work with the weekend to look forward to.

The last thing this young Indian

exposure to someone infected with the virus, expected was to be accused of carrying the virus and being confined at a quarantine centre.

Yet, that is what she had to undergo when she spent more than 24 hours in a hospital room last week with individuals who had recently returned from other countries and could have been possible carriers of the virus.

Ms Akhropele is from Nagaland, one of India's eight northeastern states populated by many ethnic communities that share facial features with people from China.

But someone in Ahmedabad, the capital of the western Indian state of Gujarat, where she had lived for the last five years, thought she and her

Asian woman assaulted in Manhattan, blamed for coronavirus: cops

In 2020, COVID-19 started spreading worldwide. I was in lockdown in Malaysia, and each day, there was news about increasing racial harassment and violence against Asian people and communities in the West. I felt overwhelmed and compelled to create a piece in response to these racist attacks. Art supply stores were all shut, so I used soot and leftover bamboo mat, since these were accessible materials at home. I also included newspaper clippings of the attacks and weaved them into the artwork to create a more pixelated look.

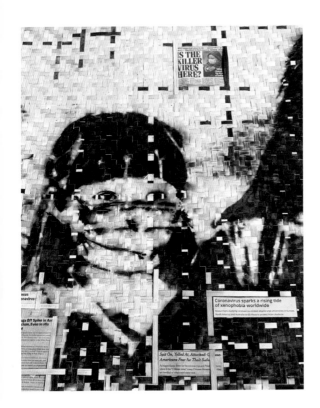

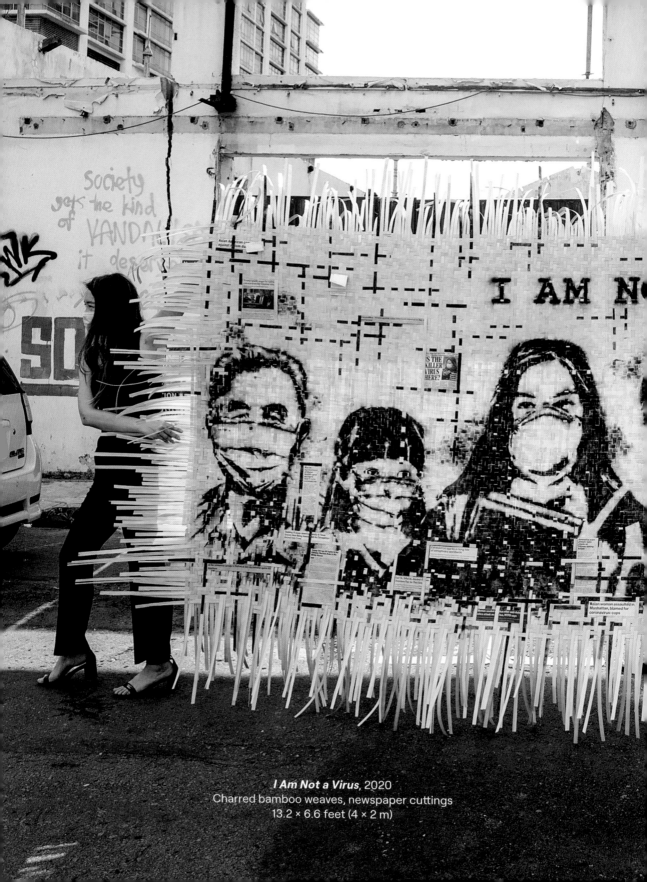

I Am Not a Virus, 2020
Charred bamboo weaves, newspaper cuttings
13.2 × 6.6 feet (4 × 2 m)

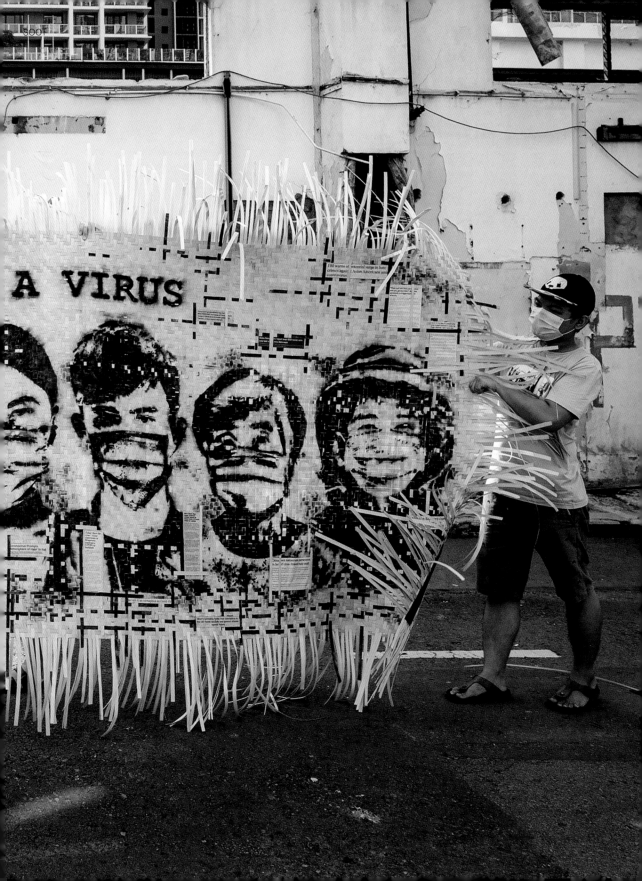

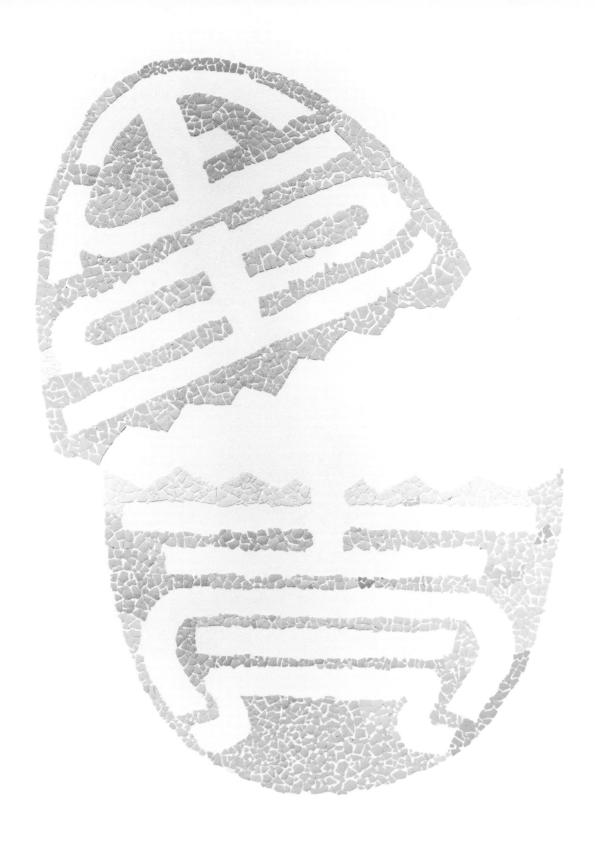

dàn ké

EGGSHELLS

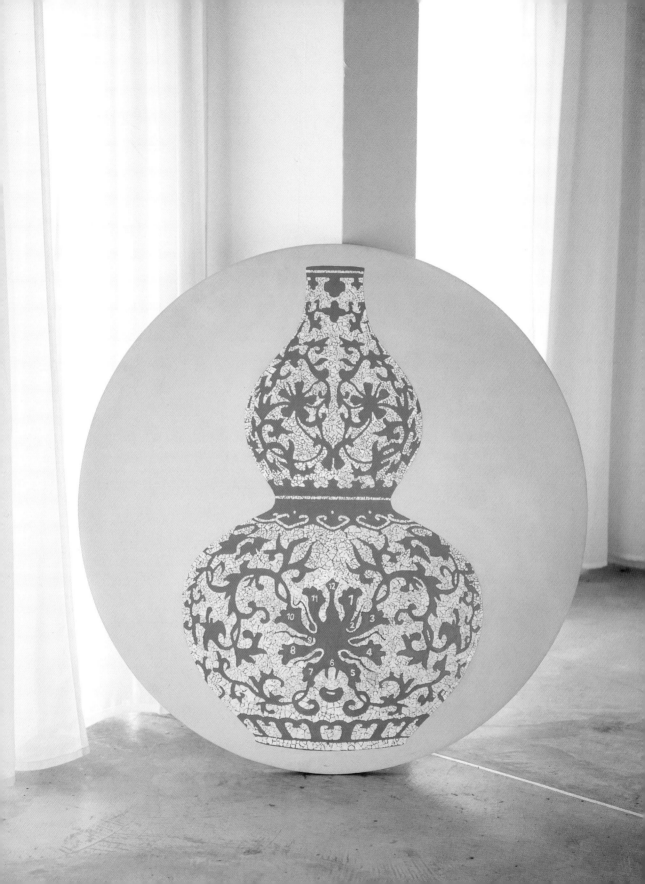

2018–ONGOING

"她是一个花瓶," I heard my friend say about a woman passing by, a few years back when I was living in China.

"She's a vase?" I asked back.

"Yes. Pretty on the outside, empty on the inside."

That was the first time I had heard of a woman being compared to a vase. That imagery stuck with me as I got older and began to reflect on topics such as careers, marriage, fertility, and the meaning of being a woman of Asian heritage. I knew I wanted to work on a series of paintings featuring traditional Chinese vases—but with what material? I kept mulling over the idea because no object seemed suitable or strong enough to portray and express these themes.

In 2018, still pondering the idea of women and vases, I traveled to Jingdezhen, the porcelain capital of China and a city that has been producing ceramics for at least one thousand years. As I explored its factories, I noticed many discarded, broken, and imperfect ceramic pieces that had not met production standards. This made me think about my own experiences as a woman, of feeling *less than* whenever I fell short of meeting societal expectations. I also came upon the Japanese art form kintsukuroi, the practice of mending broken edges using lacquer and gold. Thinking about kintsukuroi provided comfort and consolation, as it reminded me to embrace my own flaws and imperfections. And then, as I was noticing these fragmented porcelain pieces, it occurred to me that they resembled eggshells. Eggshells! They were the perfect medium, encompassing fragility, fertility, and femininity all at once. I immediately dove into researching and experimenting with the material.

Before starting to use any new medium, I first try to research as much as I can about the history and properties of the material. This stage of the creative process is both enjoyable and intriguing, as I learn how widely humans have used common objects in their surroundings for art. At the same time, ideas and inspiration can sometimes spark from the research process, informing the visuals that I create for my artwork. I love this part of making art; it is so intriguing that humans really have used everything for art.

Through my reading, I learned that the art of eggshell inlay likely originated in China around the time of the Tang dynasty (618–907 CE). My method of setting eggshells on panels is a re-creation of the coquille d'oeuf technique, which was first invented in southern China and ancient Vietnam and later revived in the 1920s by the French artist Jean Dunand.

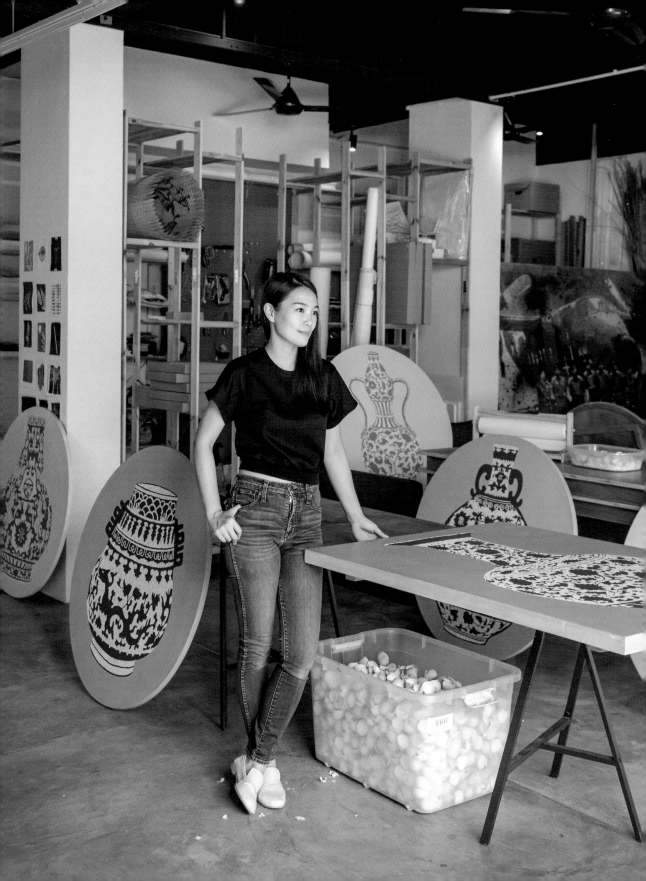

I began crafting my first vase piece using eggshells and acrylics on a wood panel, in a small studio at Hawthorne Arts Complex in Los Angeles. I created it in solitude, which was much needed for this work, and the only socializing I did was meeting with fellow artists during lunch breaks. At the time, I was struggling with personal issues in my life, and wanted to break the impossible ideals of perfection and immaculateness that women are often subjected to, and instead emphasize the beauty of irregularity and imperfection.

The first vase piece took three weeks to create—I was working full-time, up to eight hours a day! I knew that if I wanted to create a series of about ten vases, I would need assistance.

I flew back to my hometown in Borneo and reached out to female artisans to help me with this project. The three wonderful women who said yes were Danielle Soong, Venice Foo, and Elicia Lo. The four of us teamed up to create the rest of the vase pieces in the series, working in intervals for roughly a year. While we cleaned and broke eggshells, we talked about our roles and dreams as women. We shared perspectives on topics close to our hearts, such as reproductive rights and sexual discrimination, violence, abuse, safety, and other issues. Although we each had our own career goals, we also discussed the importance of celebrating our achievements as women, and being mindful about not disempowering and dividing the sexes even more. All of these discussions helped lay the foundation for expressing different ideas through my vases. This series is titled *Future Relics*, and although it began in 2018, it is still a work in progress.

Eggshell Data

10	artworks
3.2	feet (1 m) diameter round timber boards
At least 300	chicken eggs
Probably 100	duck eggs
12	months (and counting!)

Clocked, 2018
Eggshells and acrylic paint on timber board
3.2 feet (1 m) diameter

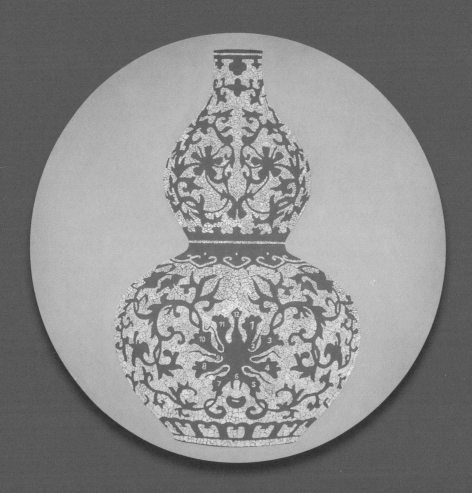

Through these works, I express the way Asian women are perceived. The piece that expresses vulnerability for me is titled *Clocked*, and the vase resembles an hourglass-shaped figure of a woman. Flower motifs represent her breasts, a clock represents her uterus. This vase expresses the pressures I feel as a woman to procreate by a certain age, and the fear of ridicule and being seen as a "leftover woman" for not meeting that deadline.

Yellow Stars, 2018
Eggshells and acrylic paint on timber board
3.2 feet (1 m) diameter

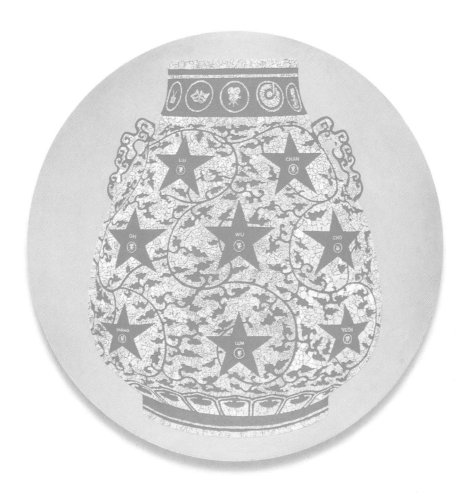

Another one of my favorites is *Yellow Stars*, a piece that features eight stars dispersed across the vase, with Asian surnames on each star. Eight is a lucky number in Chinese culture, and the color yellow is used to resemble the color of stars, of skin, of one's self-image. I wanted to express my happiness and gratitude in seeing more female Asian names featured in Western media. Representation truly matters if we are to break gender and racial stereotypes. Although I grew up mostly in Asia, the pressures of underrepresentation affect me as well because a significant amount of media that our community consumes comes from Western culture. I hope this series shows that Asian women are full people with layered stories; that we are "flowerpots" that are rich and complex.

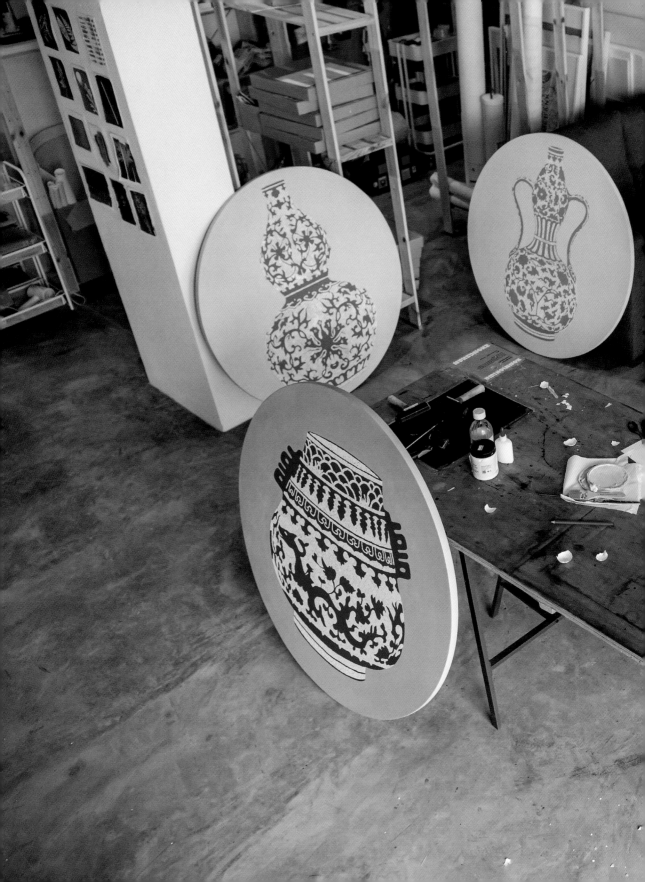

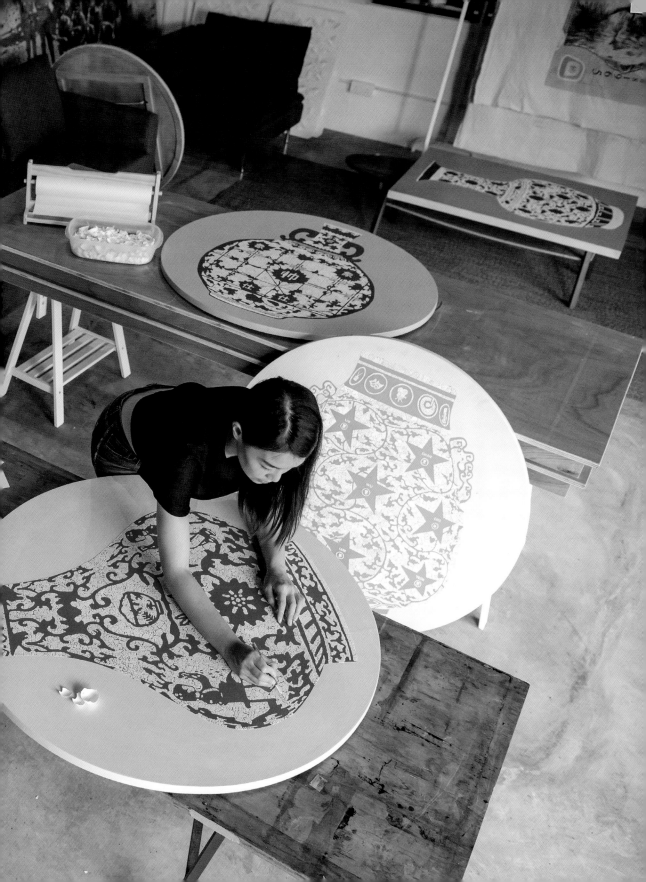

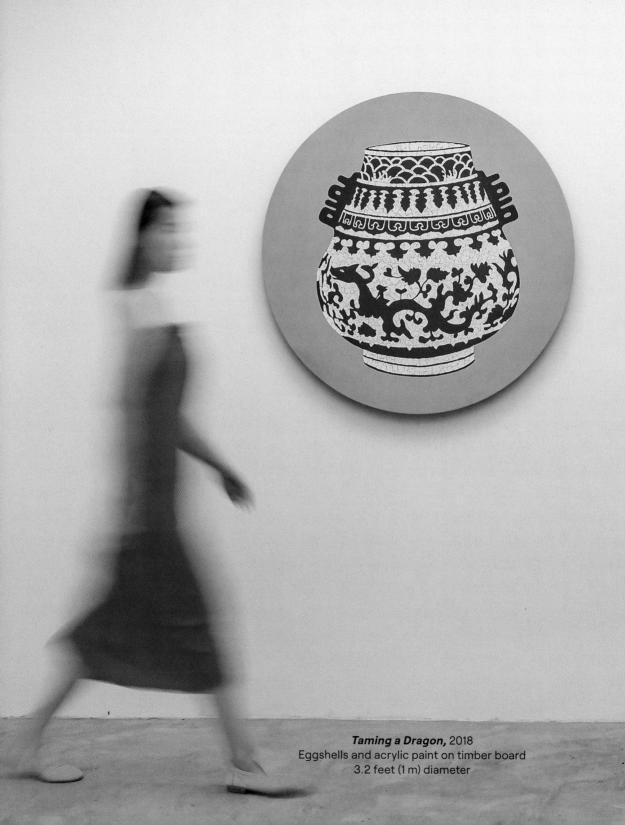

Taming a Dragon, 2018
Eggshells and acrylic paint on timber board
3.2 feet (1 m) diameter

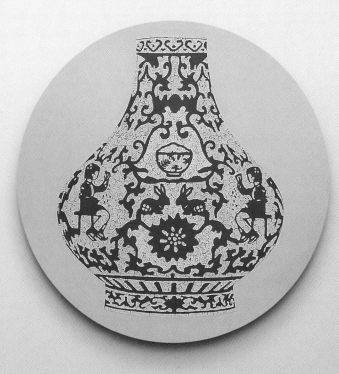

Mi Tu, 2018
Eggshells and acrylic paint on timber board
3.2 feet (1 m) diameter

Clockwise from top left:
Not Black and White, 2018
Eggshells and acrylic paint on timber board
3.2 feet (1 m) diameter

Body, 2018
Eggshells and acrylic paint on timber board
3.2 feet (1 m) diameter

Double Happiness, 2018
Eggshells and acrylic paint on timber board
3.2 feet (1 m) diameter

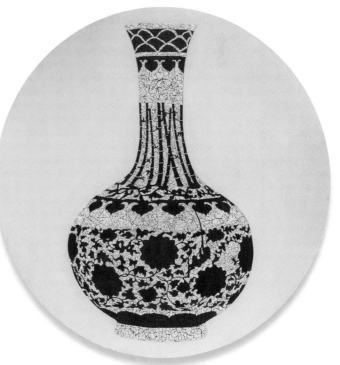

From top:
Chess, 2018
Eggshells and acrylic paint on timber board
3.2 feet (1 m) diameter

Breaking Through a Bamboo Ceiling, 2018
Eggshells and acrylic paint on timber board
3.2 feet (1 m) diameter

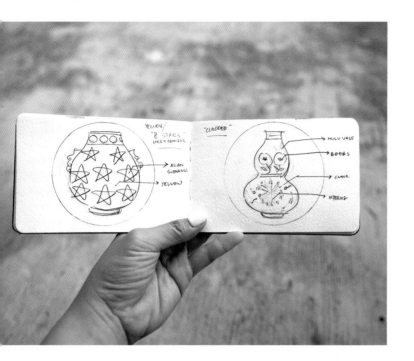

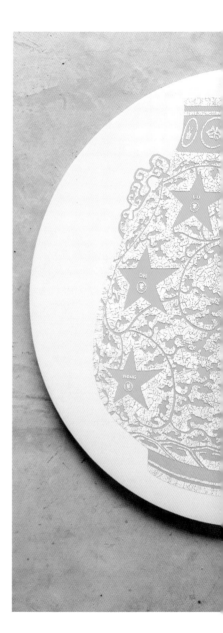

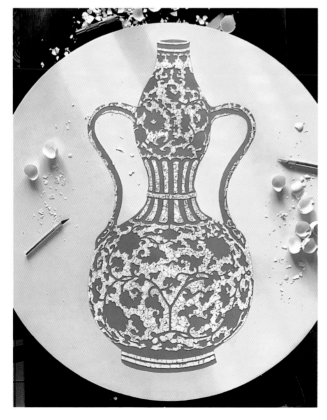

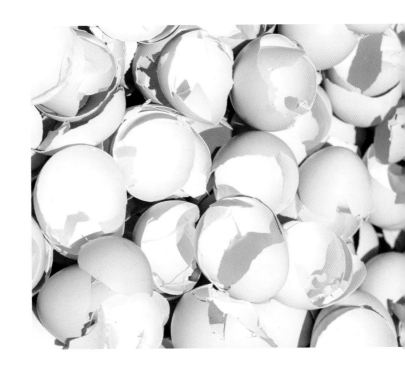

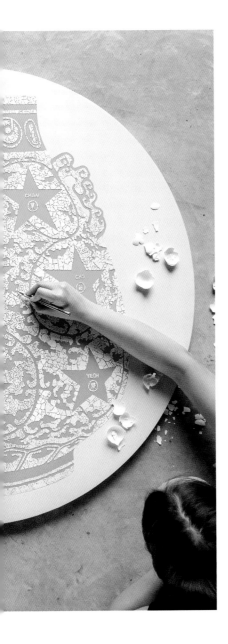

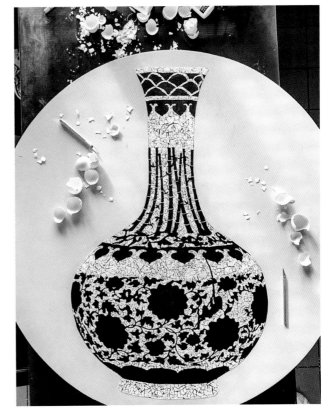

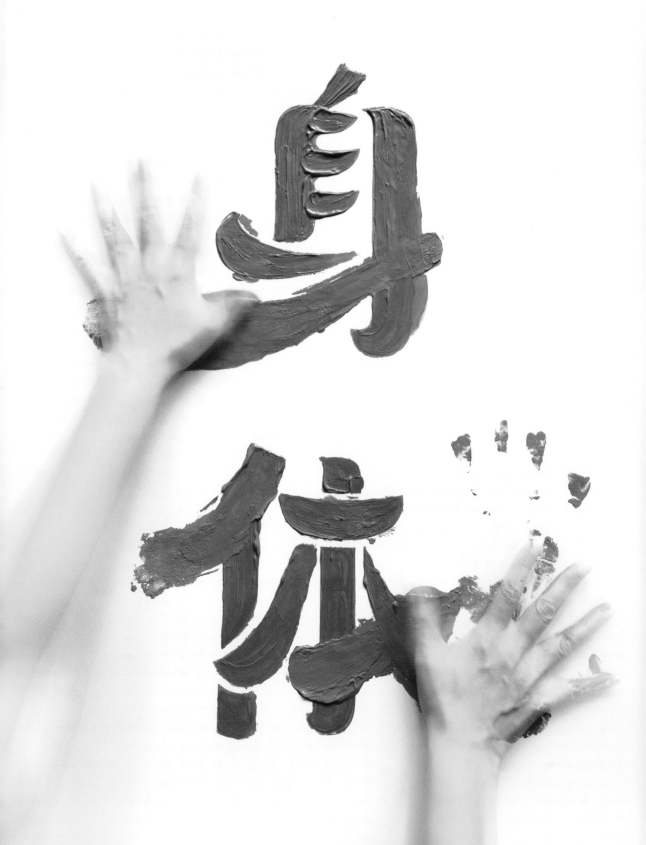

shēn tǐ

BODY

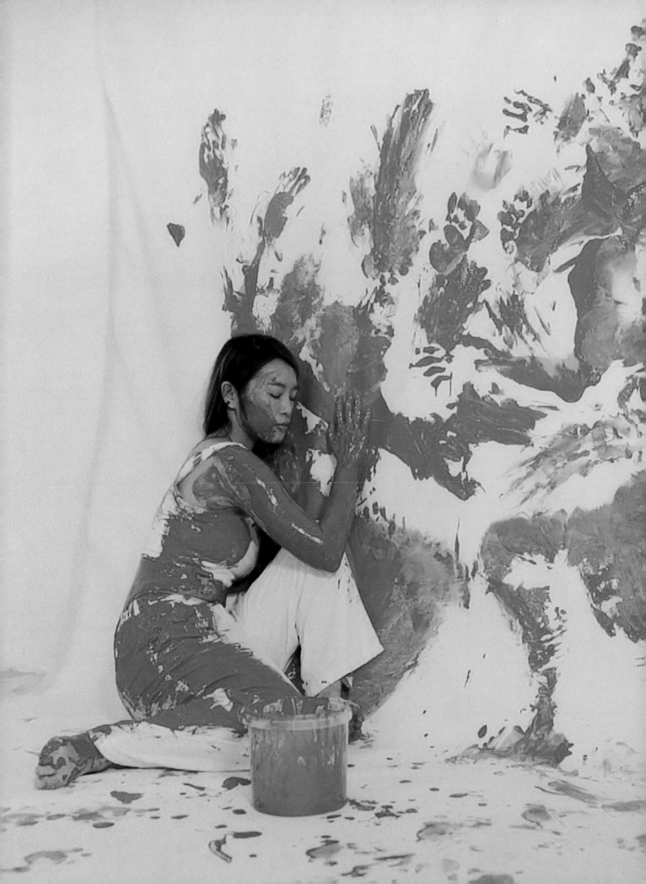

2020

In March 2020, the world went into full lockdown as a response to the COVID-19 pandemic. The days were melting into a blur, and my mind was constantly spinning. In order to cope, I knew I had to force myself to channel my feelings into something. As I searched for materials to turn into art, it dawned on me that I was spending so much time with myself, perhaps I should use myself—specifically, my body—as a tool. The absence of any other external material felt freeing and more personal. Many of my artworks have to be meticulously planned because they are so detailed; each piece requires careful calculations and laborious execution methods. In a way, breaking from that approach felt incredibly liberating. As I was exploring this method, I was reminded of the Japanese Gutai movement, which began in 1954, led by a radical artists' collective seeking to break away from traditional art styles. One of the Gutai group's most distinctive traits was their desire to reject representation and instead physically engage with a range of materials to create their art.

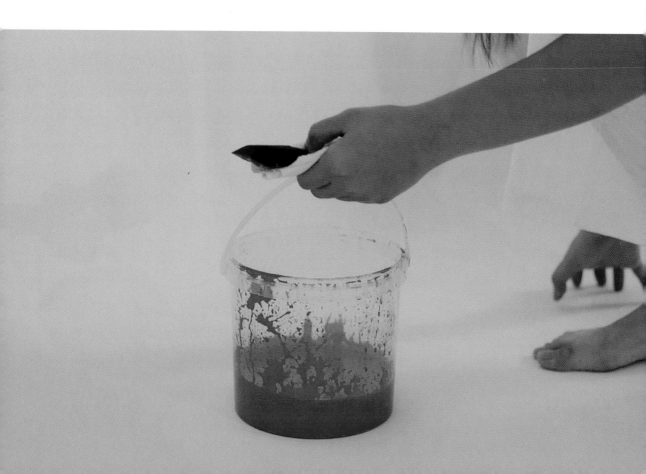

By combining the words "gu," meaning "tool," and "tai," meaning "body," the Gutai collective explored the relationship between body and matter.

Part performance art, part painting, my artwork *In Conversation* reflects this way of approaching art through human spirit connecting with matter. I wanted to express the two sides of myself, facing each other, as I wrestled with my thoughts and emotions during lockdown, coping with loss, conflict, and grief.

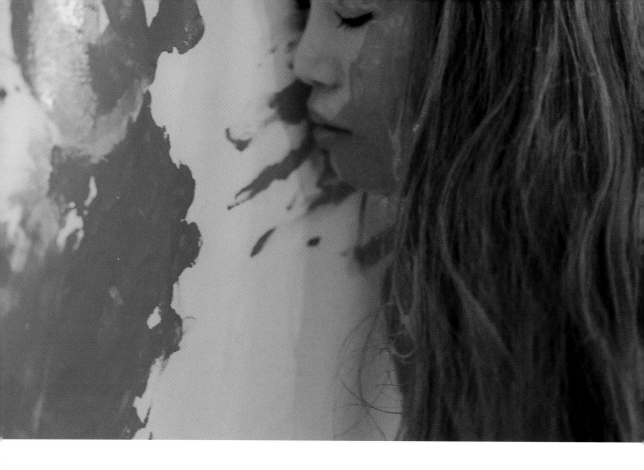

Using my fingers, feet, cheeks, and shoulders to smear paint onto canvas allowed me to express myself in a way I could never achieve with a brush. Creating this piece required movement and energy, and I felt as if I were leaving shadows of me behind when I stepped back to look at the canvas. It also felt primitive—like the ancient cave paintings that are a legacy of the prehistoric human race. This painting process also made me feel more positive and grateful about my body, likely due to the situation the world was in, with the pandemic spreading across the globe. I was grateful for a functioning body and for health. I was grateful for who I was—a vessel for a Chinese Malaysian woman. It made me happy to paint; I was free from worrying about who was going to see or buy this artwork. I just wanted to connect with my art in the most physical and personal way I could, using my body as a "brush" against the canvas.

Body Data

5'5"	–tall (165 cm) human
1	set white cropped tank top and white pants in size 4
1	bucket red paint
1	roll primed canvas
1	hour rolling around in paint

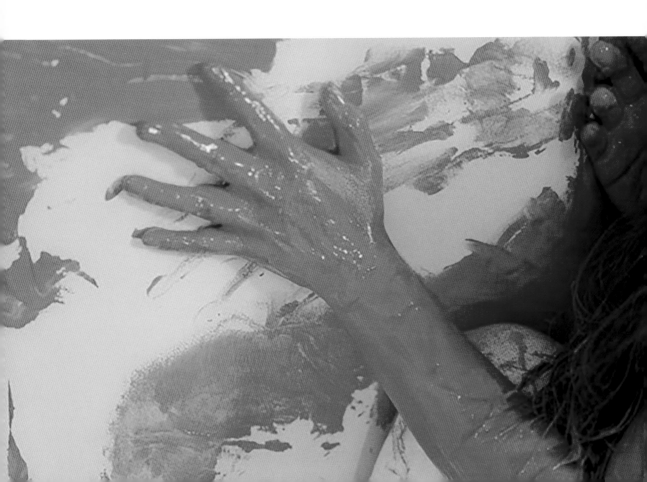

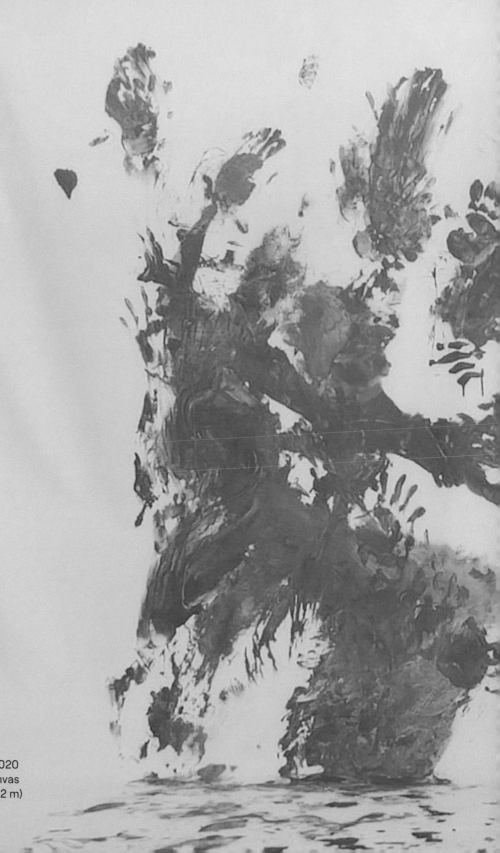

In Conversation, 2020
Acrylic paint on canvas
9.2 × 6.6 feet (2.8 × 2 m)

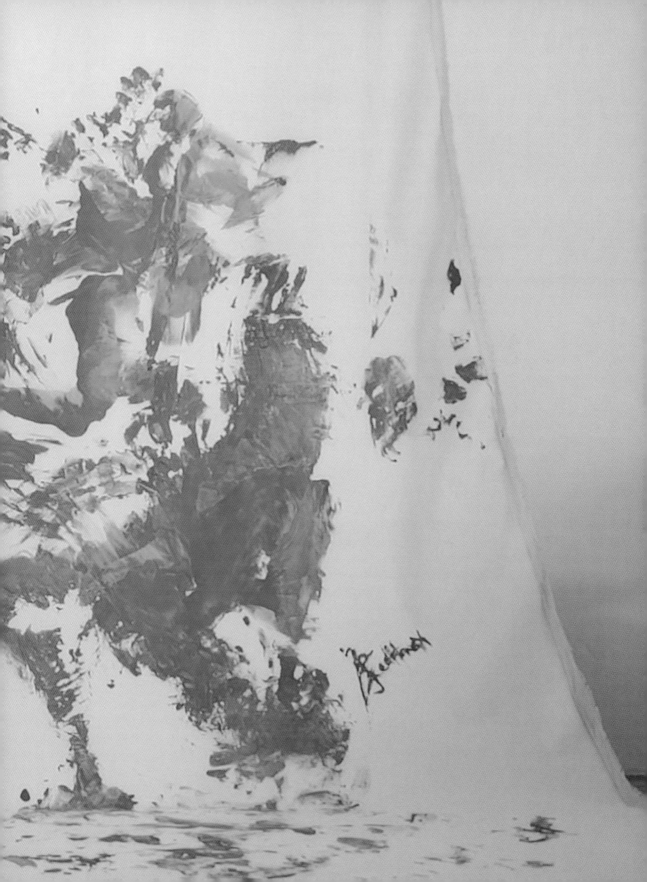

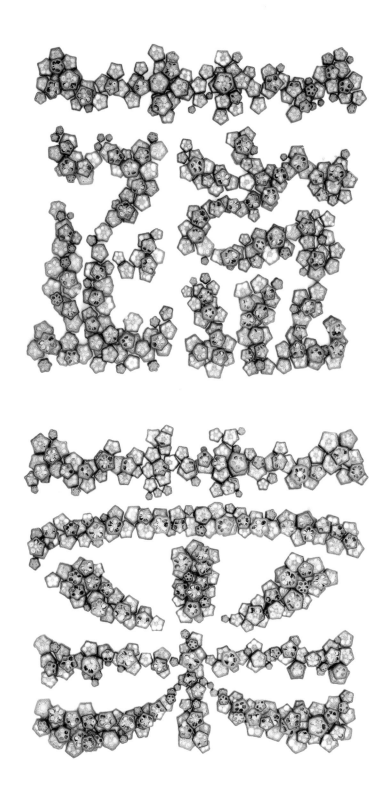

shū cài

VEGETABLES

LOTUS ROOT

FOUR-WINGED BEAN

OKRA

CELERY

6000

2200

2020

In December 2020, I was asked by a friend to create an art piece for display at the launch of his new fine dining restaurant. I liked the concept of his restaurant, and I liked this friend, so naturally I said yes! I constantly have loose ideas that I put on the back burner as I attend to projects that need immediate attention. One of these dormant ideas was to reenact a technique I learned from a kindergarten art teacher in my childhood days: to make imprints from cross sections of vegetables, or, simply put, vegetable stamping.

Vegetable Data

1	bunch okra
1	bunch winged beans
1	head celery
1	stick lotus root
19.7	feet (6 m) silk
3	weeks stamping

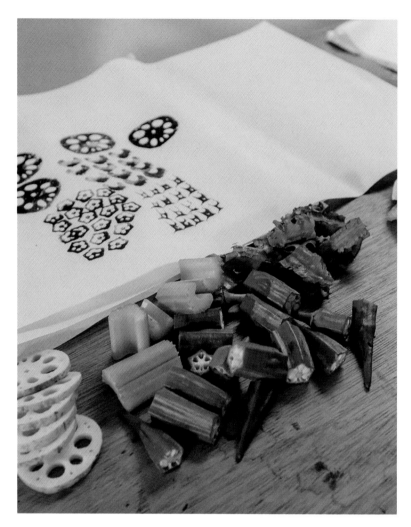

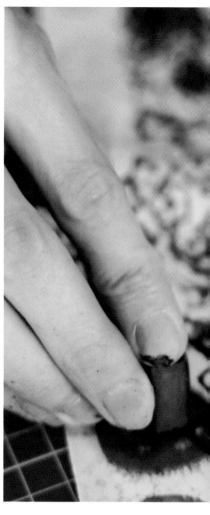

During this time, I was working with black ink in the studio. It occurred to me that I could create these imprints with black ink, which would be reminiscent of traditional Chinese or Japanese ink-wash paintings. Ink-wash paintings essentially use the same tools and techniques as calligraphy: Brushes are dipped in black ink and painted on paper or silk. Historically, Chinese and Japanese scholar-officials (also known as the intellectual class or literati) would create ink-wash paintings

as gifts for friends or patrons. Landscapes, which were regarded as the highest form of Chinese painting, were often depicted. So, with all that in mind, I turned my vegetables into my brushes and dipped them into black ink. I saw these cross sections as pixels that could be applied repetitively to form a pattern or image. Along with my team, we experimented with various vegetables from the markets and their cross sections.

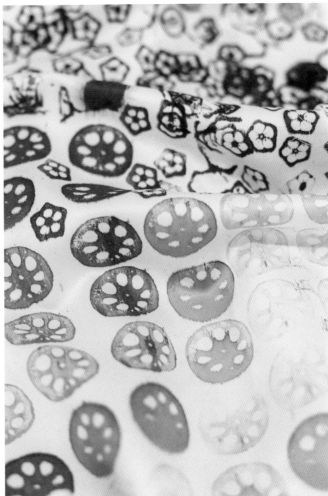

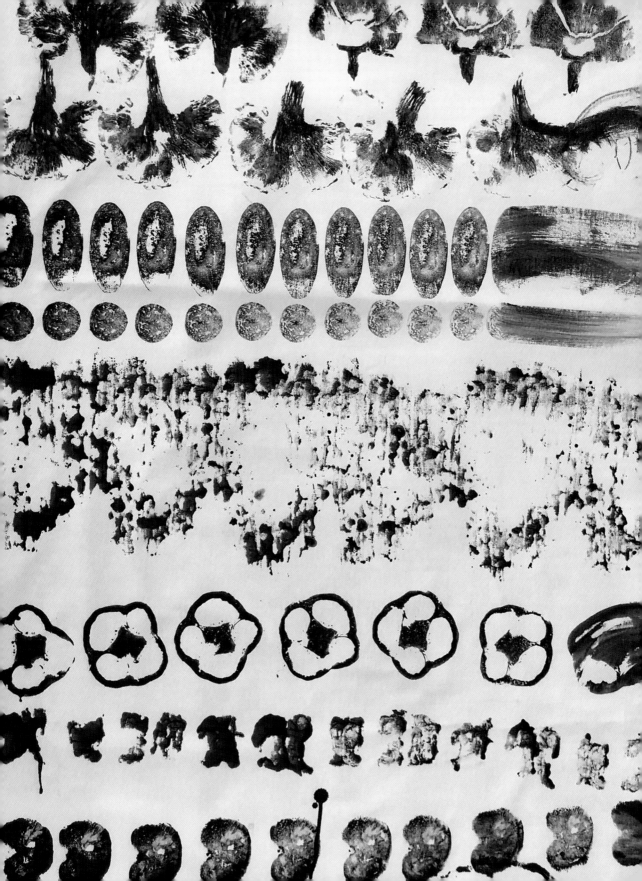

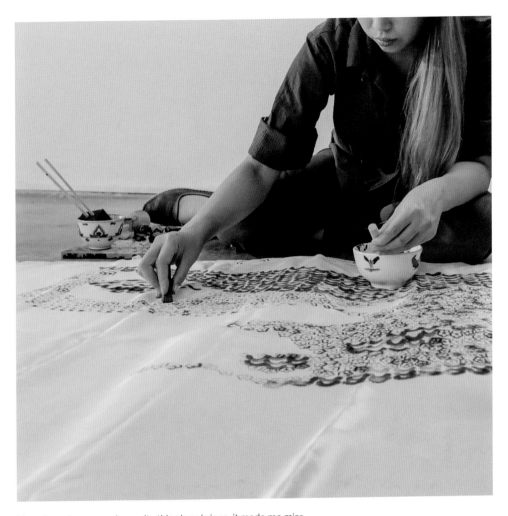

I love the calmness and serenity this piece brings; it made me miss the wilderness back when we were all locked in. I also enjoy how it was made of simple materials with a childlike technique.

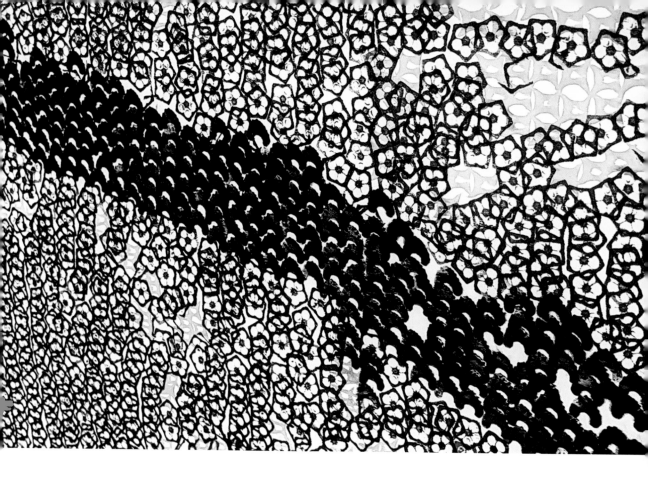

The result was a 19.7-foot-long (6 m) silk canvas covered with inked imprints from various types of local vegetables I grew up eating as a kid in Malaysia: okra, lotus roots, celery sticks, and winged beans. These vegetables held nostalgic memories for me, reminding me of childhood days when my mum would whip up tasty stir-fries for our family dinners.

Although I rarely paint landscapes, mountains have always had a special meaning for me due to my upbringing in Sabah, a state on the island of Borneo, where the indigenous peoples view mountains as sacred resting sites for spirits.

Creating this art piece felt like a humbling tribute to nature and its infinite wonders. As I filled the canvas with little inked vegetable stamps, I contemplated the cosmos and my place in it, and the humble foods that have nourished me since I was a child.

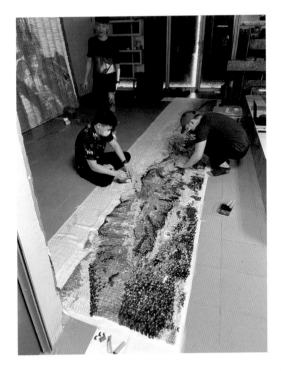

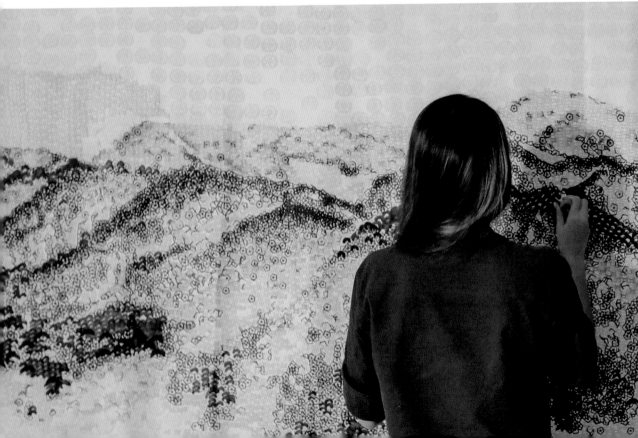

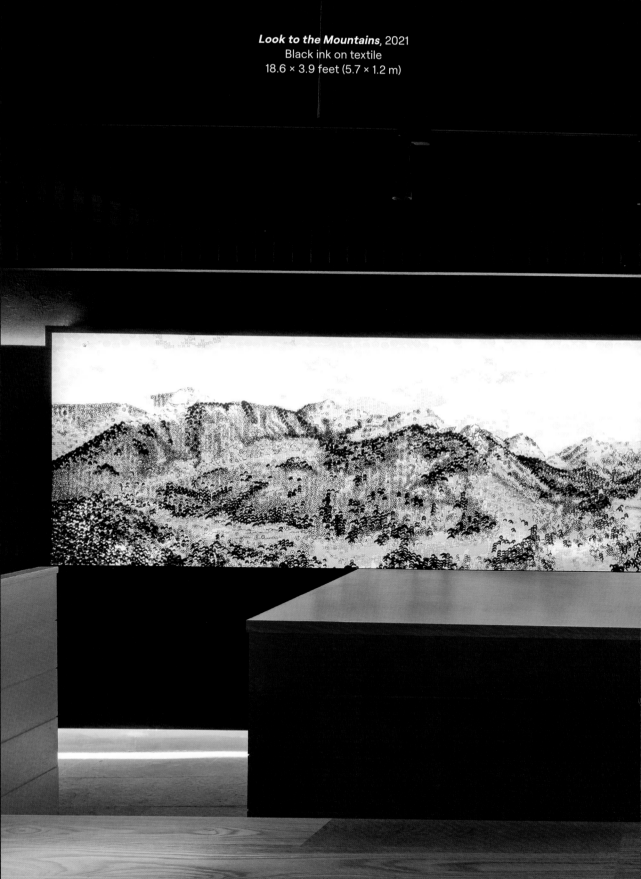

Look to the Mountains, 2021
Black ink on textile
18.6 × 3.9 feet (5.7 × 1.2 m)

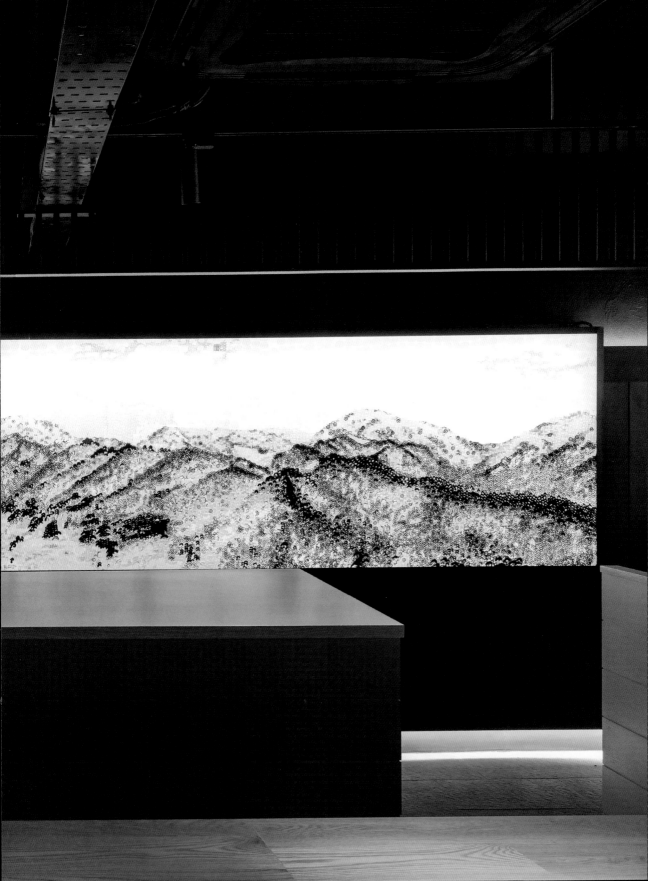

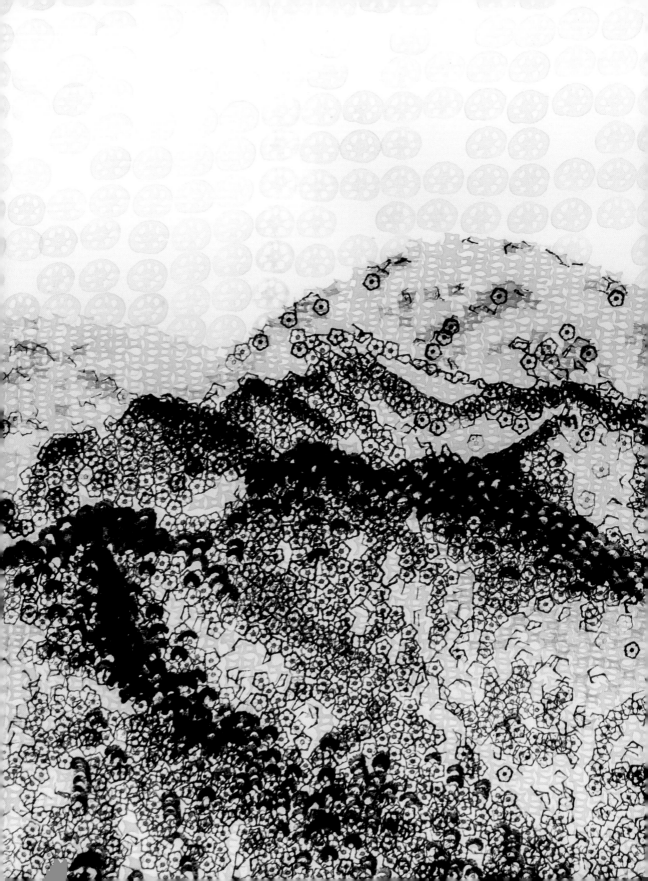

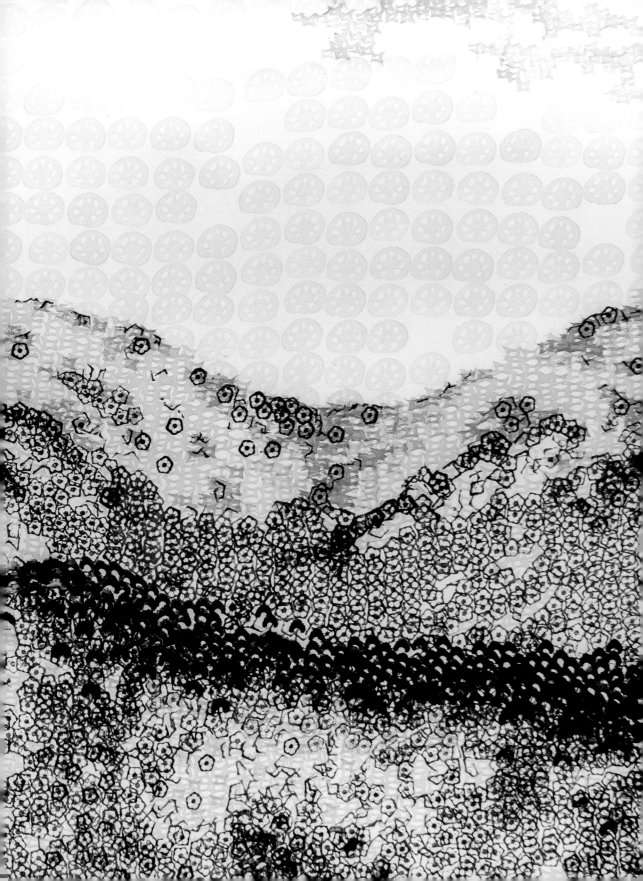

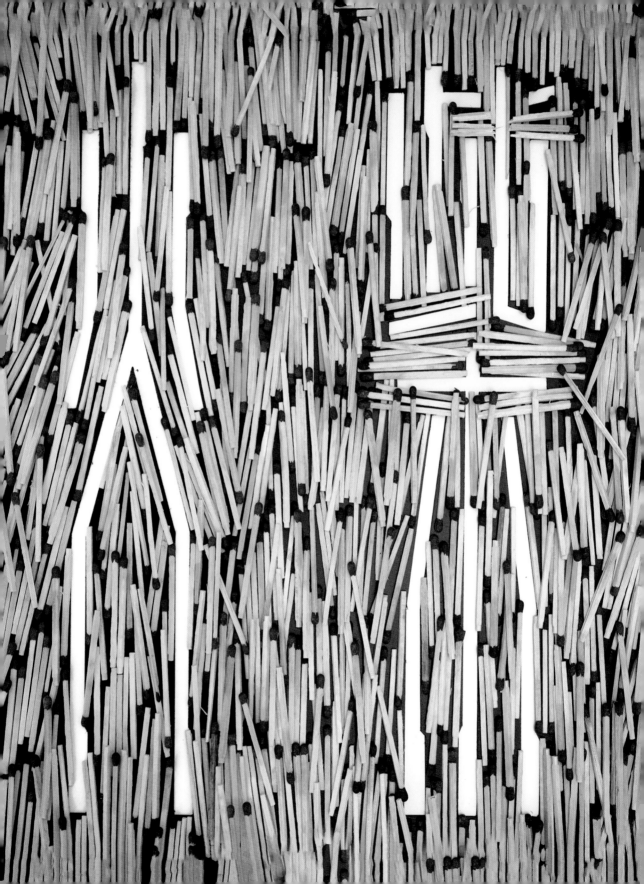

hǔo chái

MATCHSTICKS

BORDER REPLACED
WITH RUBBISH

"INSTA" PHOTO,
WITH FILTHY
SURROUNDINGS

WORLD MAP
MADE OF WOOD/
CHARCOAL

WORLD MAP MADE
OF MATCHSTICKS

TIME

TIME

TIME

TIME

BOAT
WADING
THROUGH OCEAN N
GARBAGE

GARBAGE
ON BEACH

WAVES

TILTED VIEW
OF MATCHSTICKS

APRIL 26 / MAY 3, 2021

CLIMATE IS EVERYTHING.

HOW THE PANDEMIC CAN LEAD US TO A BETTER, GREENER WORLD BY JUSTIN WORLAND

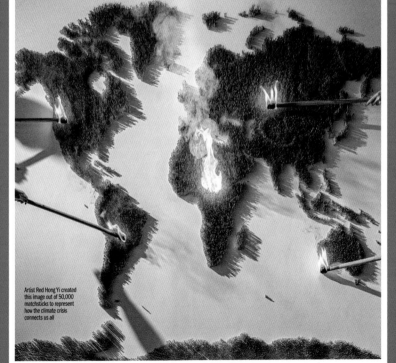

TIME

Artist Red Hong Yi created
this image out of 50,000
matchsticks to represent
how the climate crisis
connects us all

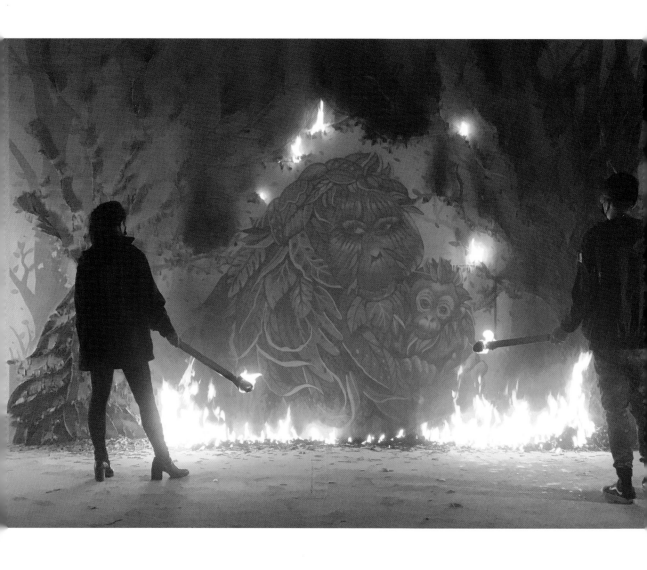

2021

Borneo's tropical rainforests are home to some of the most biodiverse ecosystems on the planet. But over the past decades, annual forest fires caused by large-scale land clearing of industrial plantations have ravaged these beautiful forests, critically endangering the orangutan and other wildlife populations by destroying their natural habitat. Both myself and Kenji Chai, a fellow Borneo street artist, felt strongly compelled to bring awareness of the environmental crisis happening in our homeland. After meeting and brainstorming in October 2019, we decided to collaborate on a piece that would combine street art and installation work into performance art, culminating in the literal burning down of our artwork. In the end, we decided on a scene depicting a mother and baby orangutan surrounded by trees. The orangutans were spray-painted by Kenji, and the trees were built with thousands of matchsticks. The whole burning process was filmed and edited into a short video by our director friend Chong Kern Wei and shared on various online platforms. What wasn't captured on camera was how stunned Kenji and I were by the speed and height of the fire that spread across the artwork. We had to extinguish it within a minute of lighting it up for fear that it would engulf the timber rafters above.

In February 2021, I received an email from D. W. Pine, the creative director of *TIME* magazine, asking if I would like to create a cover for their special April issue that would be addressing climate change. Though I had previously sent my portfolio to him, I hadn't heard back from him in a while and assumed he was not interested in my work. The opportunity to collaborate with *TIME* truly felt like a dream to me; it meant following in the wake of several artists I deeply admire, such as JR and Shepard Fairey. We had a few sessions on Zoom to discuss ideas and eventually settled on a simple, but impactful visual of a burning world map made of matchsticks. Malaysia was still going into intermittent lockdowns at that time, so I knew I had to quickly assemble a team of assistants, photographers, and videographers to get the work done by our deadline.

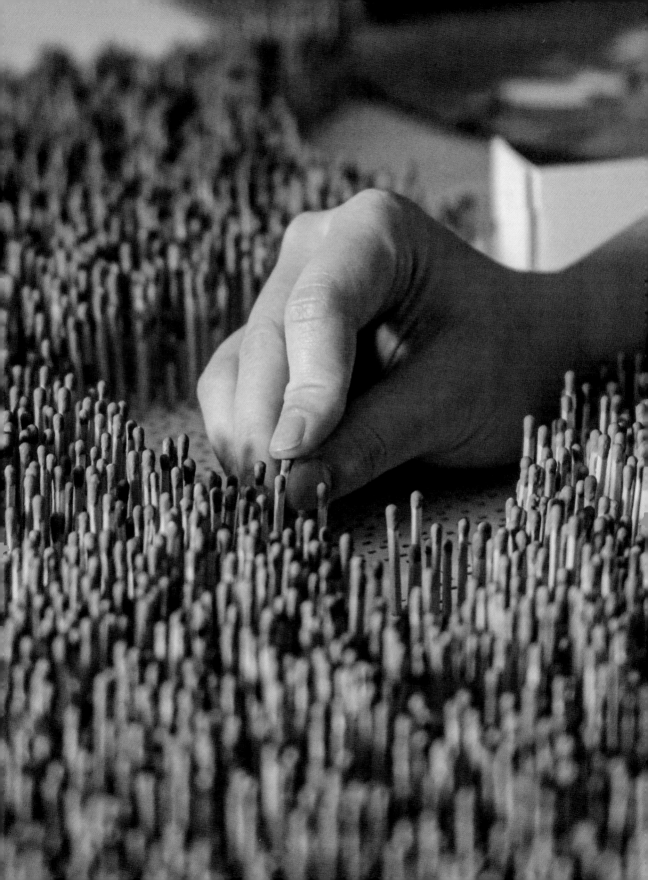

I specifically wanted to use green-tipped matchsticks to render our world map because they look like skinny trees! However, most of the matchsticks that we could source in Malaysia were either brown- or red-tipped. And we couldn't fly matchsticks in from outside the country because they would pose a fire hazard; they could only be shipped in. After much hunting, we finally found a local factory in another state that had supplies of our sought-after matchsticks in storage. By the time they arrived, we had only two weeks to get the world map built.

The physical labor of assembling the artwork was just one part of the installation process. Much earlier, a significant amount of work had to be done on computers, planning out the topography of the map. This would help speed up the process of positioning the matchsticks. Besides that, machines were used to cut precise holes onto the timber boards, so that when it came to sticking in the matchsticks, we didn't have to waste time deciding where to place them. The one thing that

did require manual adjustment was the height of the matchsticks. I felt that having a range of heights for the map would be much more organic and interesting visually, and I imagined dramatic shadows cast against them when the piece lit up.

Playing with Fire

It was both exciting and nerve-racking to know that we only had one try to get this right after we lit up the work. So, like most of my projects, I experimented with a small test piece before moving on to the actual work.

We created a test piece of a country—sorry, Australia—and made sure it was to scale, which gave us a sense of the fire's size for the actual piece.

The way the fire engulfed our test piece excited my team but worried me; after the experience of creating the artwork with Kenji, I knew how difficult it was to manipulate fire. If we were not careful, it could easily get out of control.

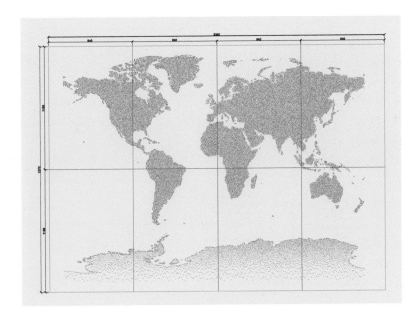

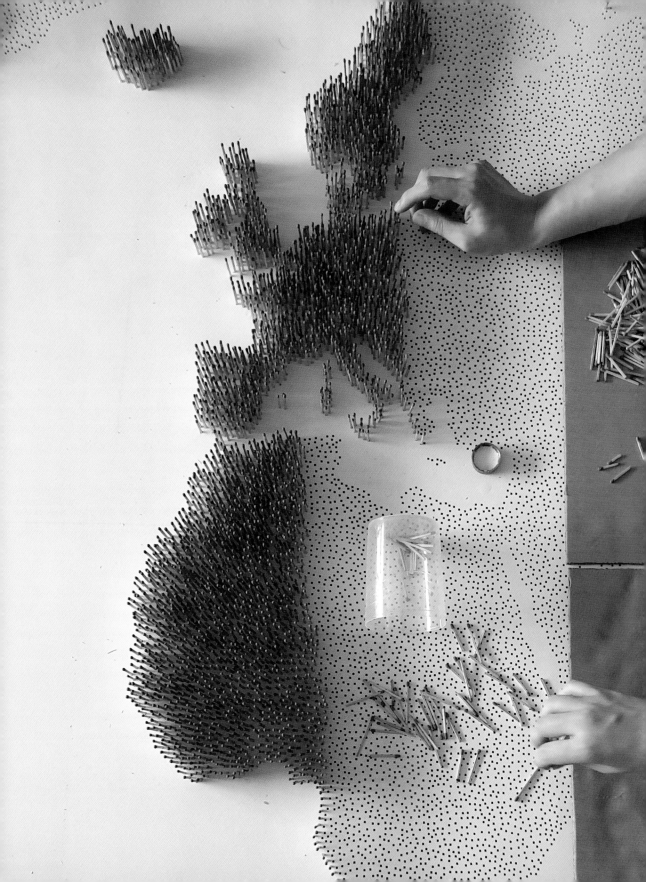

For two weeks, I worked with five people from my team; we spent up to eight hours daily sticking fifty thousand matchsticks onto a board measuring approximately 11 × 7 feet (3.4 × 2.1 m). It was back-breaking work, and I was astonished at how long the assembly process took; after a full day's work only a fraction of a single continent would be finished. It struck me that, just like the environment, the artwork could take eons to create, but it could also be destroyed in a very short amount of time.

Matchstick Data

50,000	matchsticks
11 × 7	feet (3.4 × 2.1 m) timber board
1	bucket fire-retardant paint
6	people to assemble
3	photographers
3	videographers
2	fire-safety crew members
150	hours

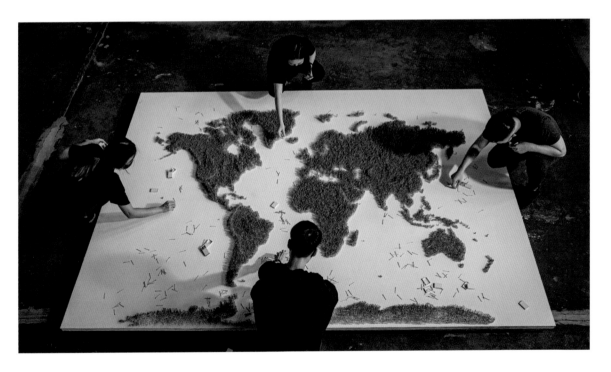

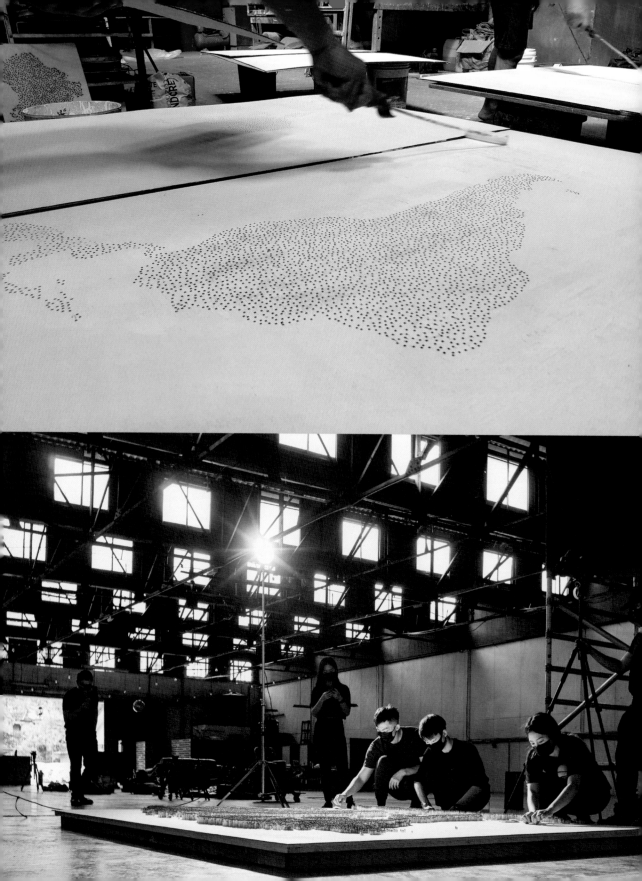

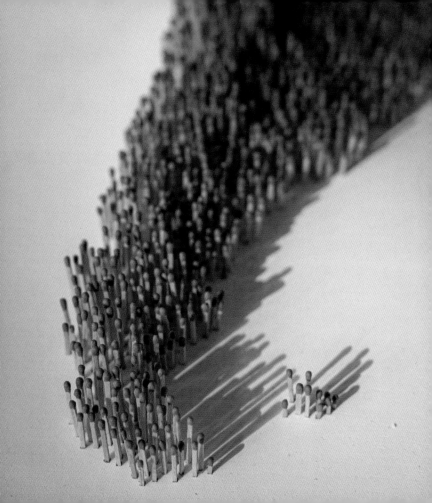

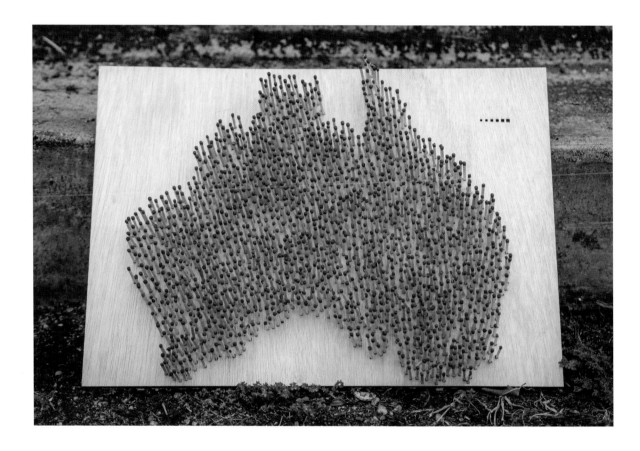

Our experiment yielded several important lessons for the team, as we strategized how to create the final piece: First, the artwork had to be tilted 45 degrees to reduce the height of the fire, and second, the timber board needed to be treated with fire-retardant spray to prevent the fire from spreading and destroying the board. Only the matchsticks would catch fire, to achieve the visual burning effect.

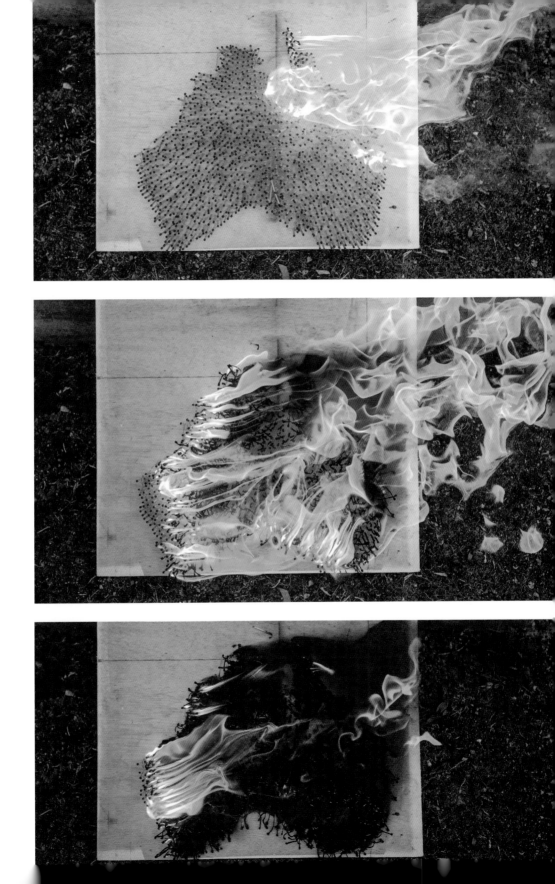

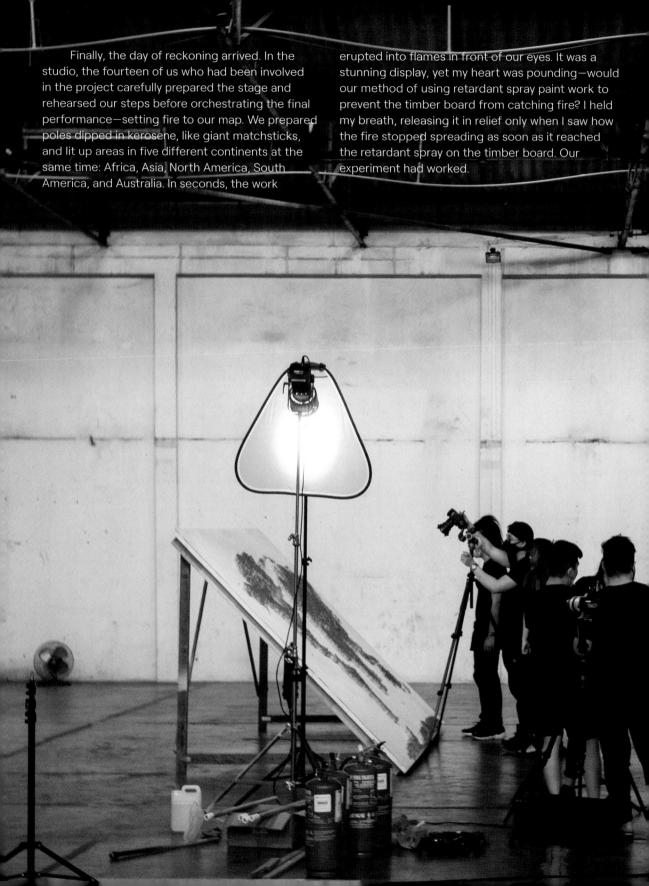

Finally, the day of reckoning arrived. In the studio, the fourteen of us who had been involved in the project carefully prepared the stage and rehearsed our steps before orchestrating the final performance—setting fire to our map. We prepared poles dipped in kerosene, like giant matchsticks, and lit up areas in five different continents at the same time: Africa, Asia, North America, South America, and Australia. In seconds, the work erupted into flames in front of our eyes. It was a stunning display, yet my heart was pounding—would our method of using retardant spray paint work to prevent the timber board from catching fire? I held my breath, releasing it in relief only when I saw how the fire stopped spreading as soon as it reached the retardant spray on the timber board. Our experiment had worked.

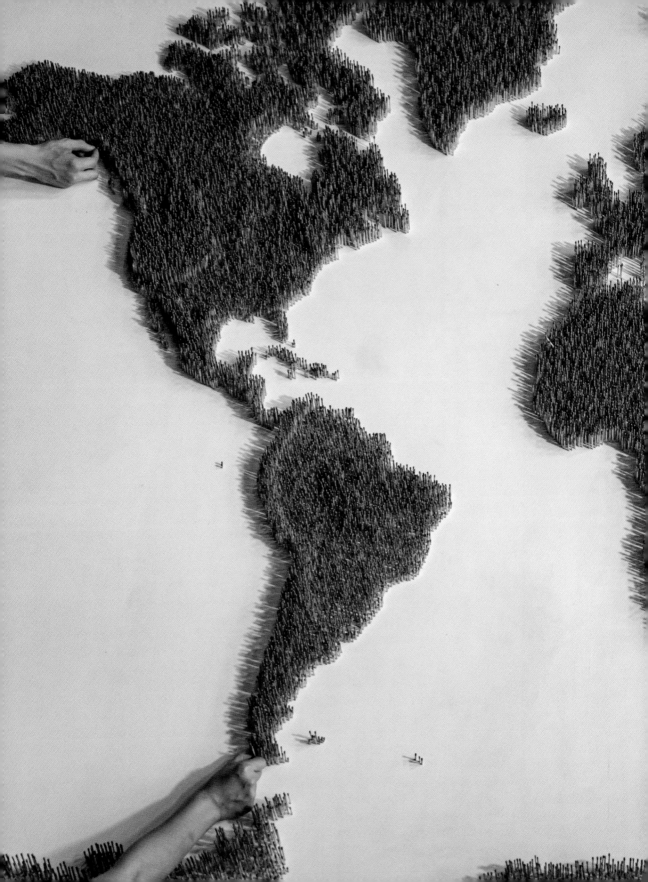

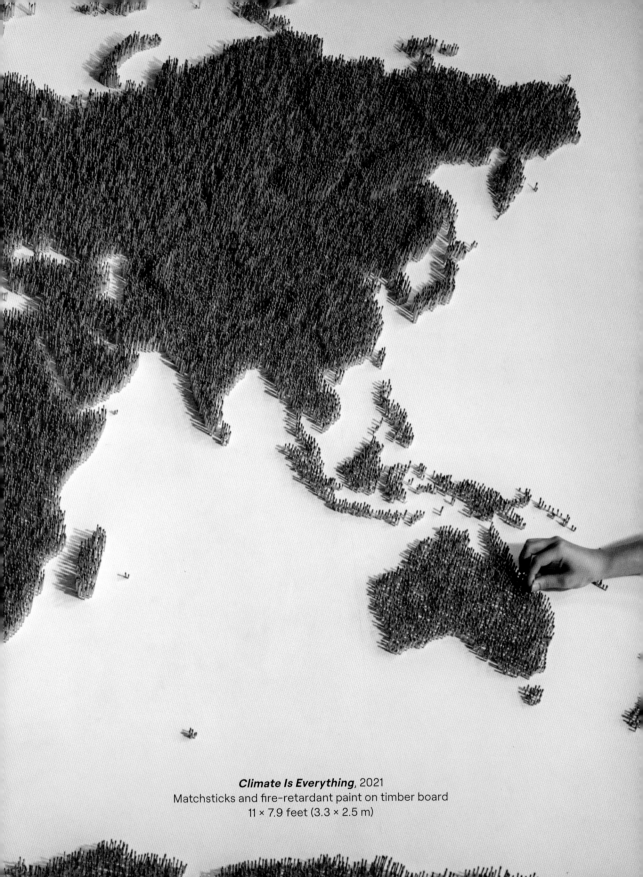

***Climate Is Everything**, 2021
Matchsticks and fire-retardant paint on timber board
11 × 7.9 feet (3.3 × 2.5 m)

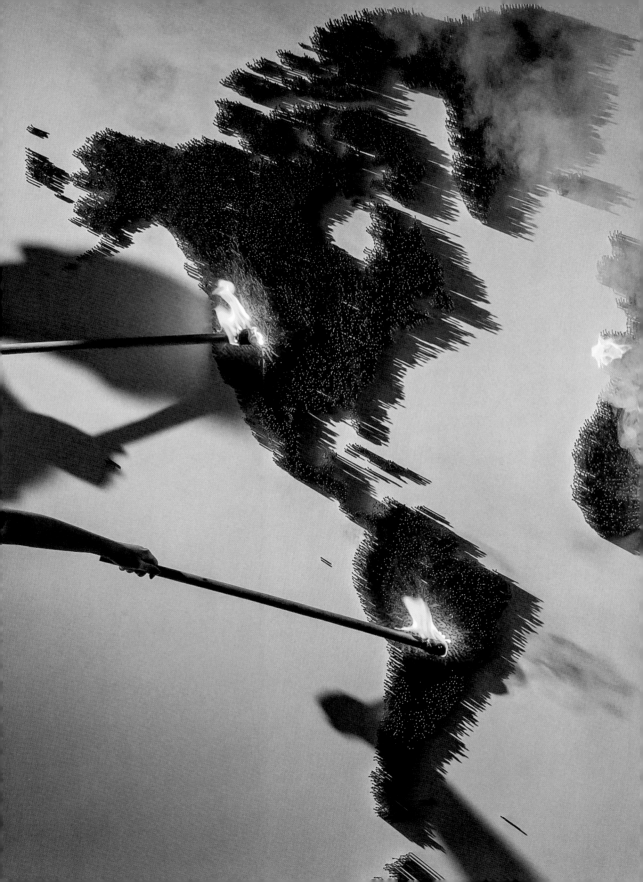

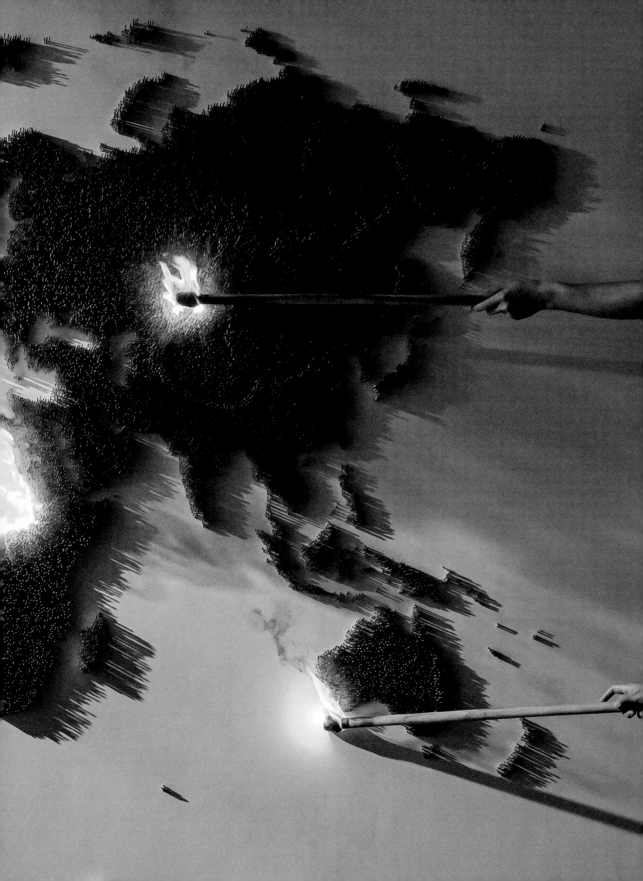

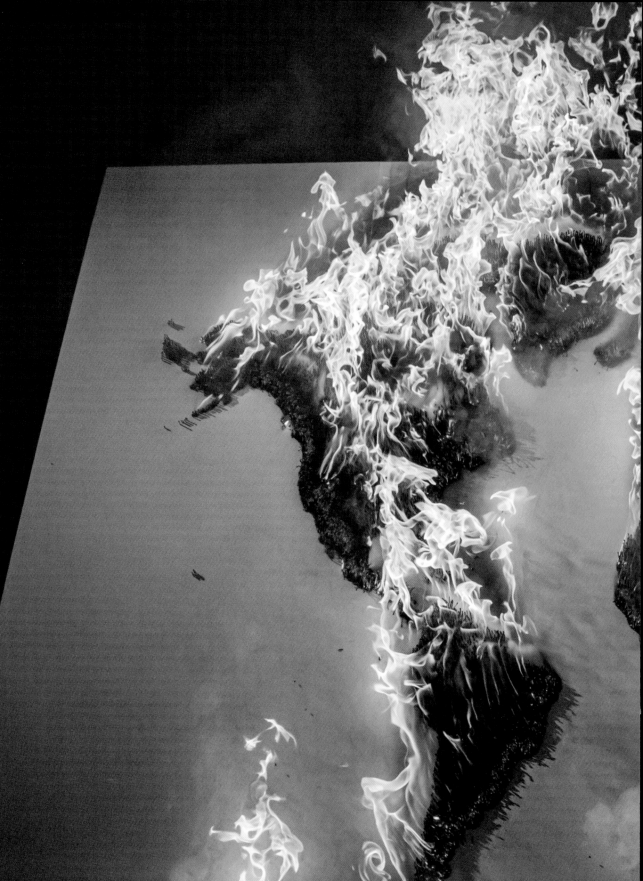

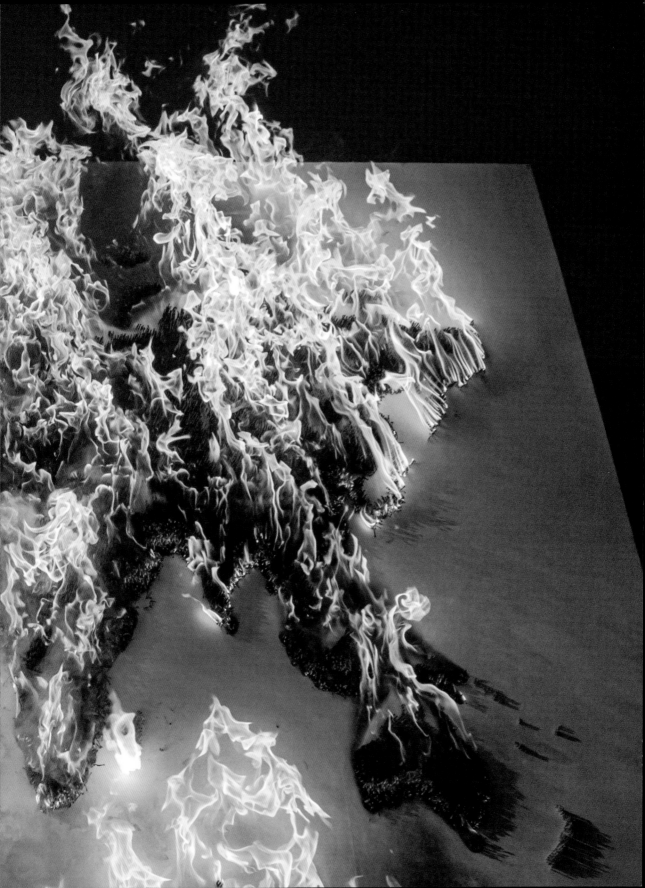

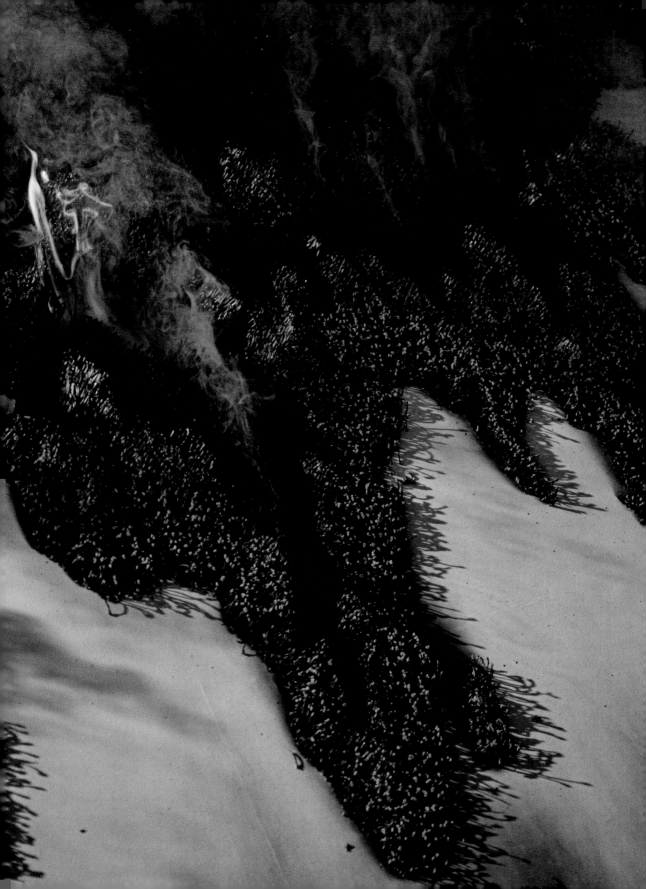

In the end, all the continents on our map burned except Hawaii and New Zealand. Everyone was clearly stunned by the sheer intensity and energy of the fire, and we joked that we all knew where we should move!

As I watched the flames engulf the artwork, I thought about the unprecedented times we are living in, as the pandemic continues to assail the world. More than ever, it made me realize that no country is untouched by a global crisis, whether it is a pandemic, an economic collapse, or, as this art piece highlighted, global warming and climate change.

The *TIME* special issue on climate change was published and released worldwide on April 15, 2021. It was truly an honor to create this artwork, and I'll forever be grateful for the opportunity.

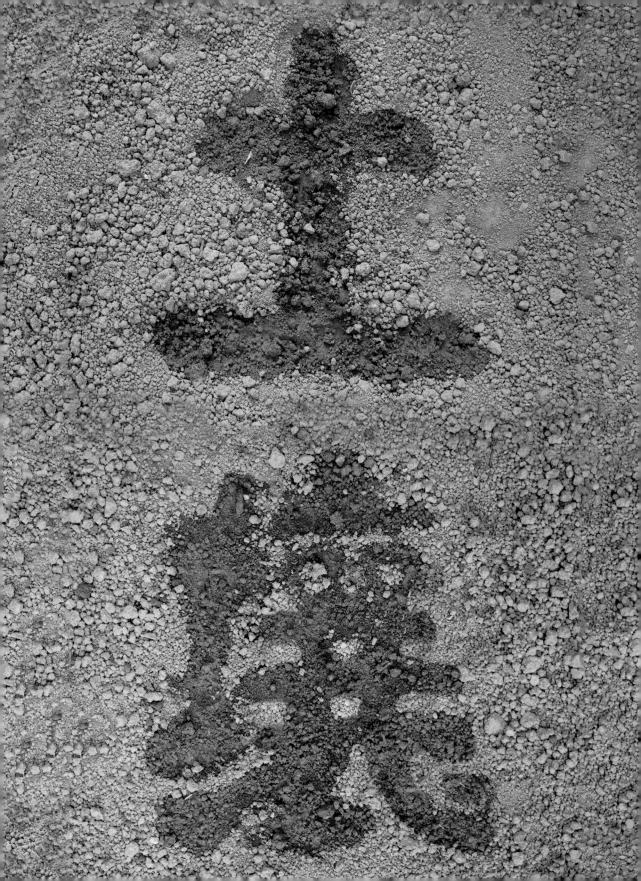

tŭ răng

SOIL

Soil Data

4	soil types
1	bag dried branches
1	bag dried leaves
5	buckets resin
12	people
250	hours

2021

In November 2020, Alvin Teoh, the son of Malaysian war veteran Major Andrew Teoh Hoot Aun, contacted me to ask if I would be interested in creating an artwork as part of a feature documentary about war veterans from the Malaysian Armed Forces in the 1960s. The project immediately appealed to me—one of my missions as an artist is to tell stories, meaningful ones, about history, culture, and heritage.

From the start, we knew that soil, or tanah in Malay, would be the material to symbolize the two major wars fought by our veterans—the Malayan Emergency (Darurat) and Konfrontasi (Confrontation). Beyond just recounting these events, I wanted my piece to go beneath the surface to capture the pain and reality of war, how it had affected the veterans' lives as well as that of their families, while also reflecting the deep love they have for their country. As part of the research, I spoke to several veterans to learn about their experiences. I was able to meet two of them—both octogenarians—in person before lockdown, while the rest I met via online meetings through Zoom.

As an East Malaysian from Borneo, I wanted the artwork to present the East as equal to the Peninsula. I was adamant about sourcing soil from both regions, even if lockdown made it difficult to get the materials. The East Malaysian states of Sabah and Sarawak have vastly lagged behind the West in terms of infrastructure and development, despite being endowed with abundant natural resources. Much of these resources were channeled into the West, putting them on a completely different trajectory of development.

With my team and fabricator, we created three artworks by referencing actual photographs of the veterans that were taken in the 1960s, sourced from Major Andrew's personal collection. Major Andrew kept many letters and photos from back then, and it was very special that he shared them with us. We chose three images: the first showing the veterans and the airplane they flew in; the second showing Major Andrew's wedding day, with words by Major Patrick Wong Sing Nang; and the third showing the pain and realities of war.

Their stories were both inspiring and heartbreaking. Some had not been able to see their families for months on end, and missed seeing their children grow up. Many had lost close friends in combat. It touched me deeply to know there were so many Malaysians of all races, beliefs, and

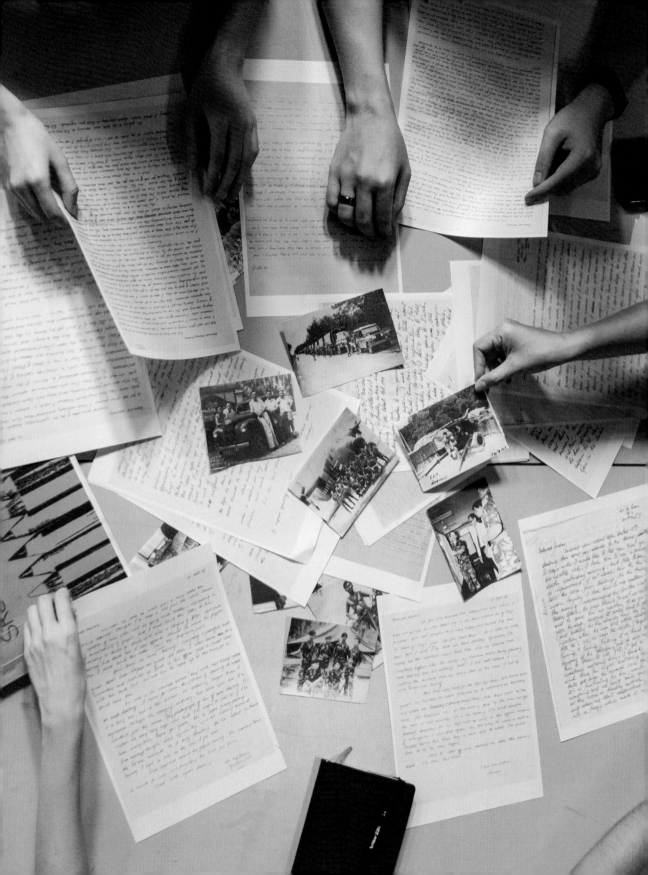

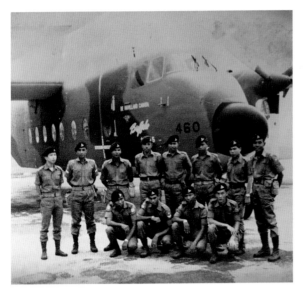

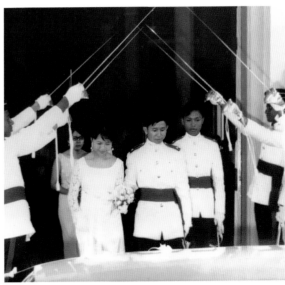

[handwritten letter]

Pictures and letters were selected and later on were projected on the wall in a grid layout to map out work.

backgrounds, from both East and West Malaysia, who had sacrificed so much for our country. One of them said to me, "Why would race matter when you're fighting for your country?" They knew the cost, but also understood that someone had to do it.

Three photographs provided by the veterans served as the references for our artwork. We first enhanced them digitally on the computer, as the original photos were of a low-resolution quality.

Using a methodical Renaissance-era drawing technique, we first drafted a grid over a print of the original photos, and then sketched it box-by-box onto an enlarged gridded timber panel measuring nearly 8 × 5.3 feet (2.4 × 1.6 m). For more detailed visuals, we projected the image with an overhead projector in a darkroom. We applied base paint, resin, and soil in different shades, and then added other objects such as loose wood chips, twigs, and charcoal.

The soil was intentionally rendered in a muddled way and without precise clean lines to blur the appearances of the veterans and keep their identities concealed. In the wars they fought, each had defended and sacrificed equally for their country.

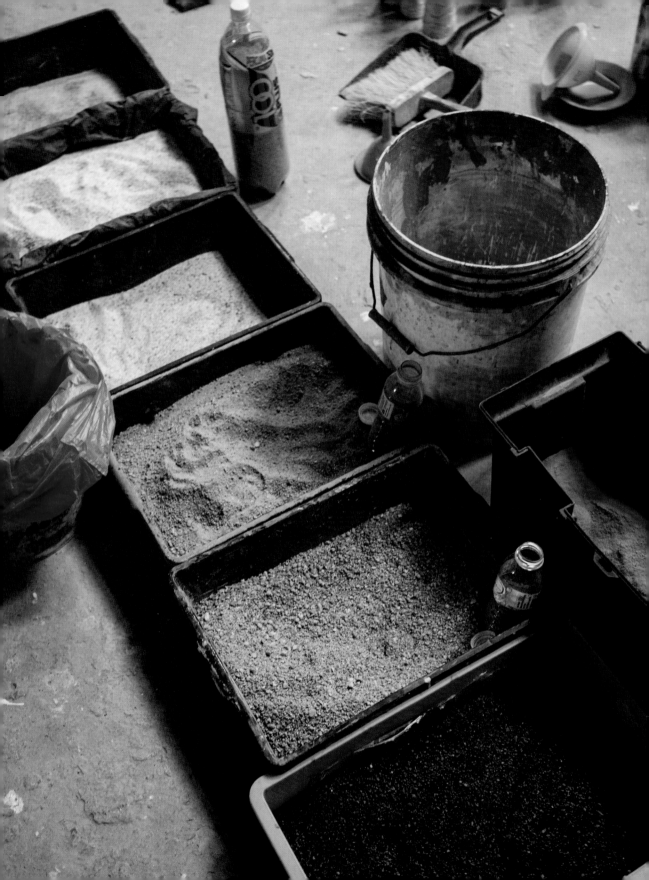

Tanah Tumpahnya Darah Kita
("The land on which our blood was spilt")

More than twenty-two different types of soil, rocks, and leaves were sourced for these pieces. Because soil is organic, we had to go through a process of treating and drying it first. Then it was placed onto timber boards and sealed with resin. I admired the texture and tactility of the soil as it gave the imagery an abstract quality, opening up space to hold more complex meanings beyond what was visibly depicted.

In one of the three soil art pieces, we embedded replicas of letters written by Major Andrew to his wife, Andrene, during the war, while they were separated. He wrote more than one thousand letters to her! We scanned and printed selected copies of these letters to look as close to the originals as possible. We were so moved by these texts that we had to include them in the artwork. Overlaying the same art piece are the words "My bride let me run off to battle on our wedding day; she knew my country always came first" from Major Wong. They come from the draft of his book, in which he recounts the sacrifices his wife made. The line refers to the memory of being called away to fight on the fields on their wedding day, and how his wife obliged. "The wives are the unsung heroes," he told me. "They were willing to marry army men who would probably never return home."

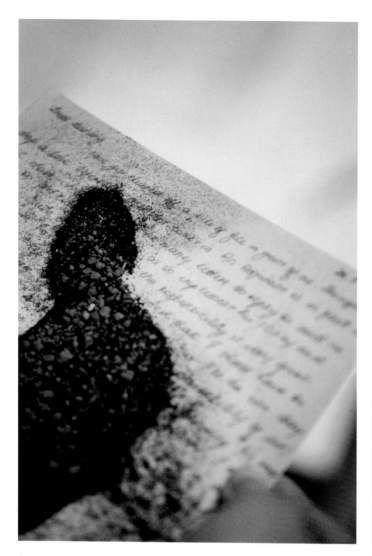

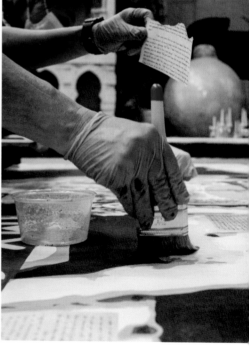

Original photos from the veterans were scanned and digitally enhanced. Using overhead projectors, the photos were traced on a board. Soil and photocopies of letters from the veterans to their families were then laid and glued to the board.

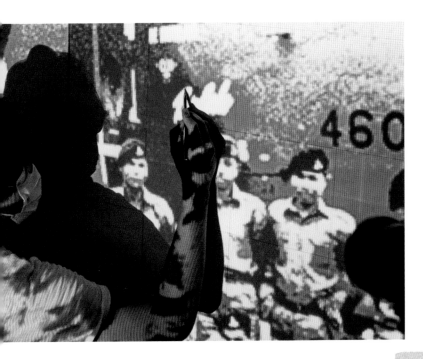

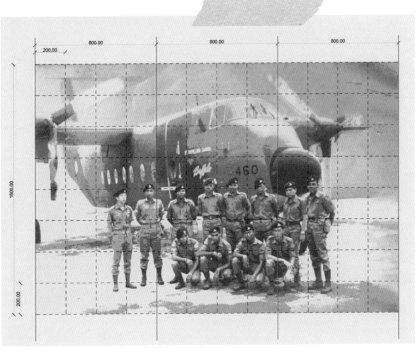

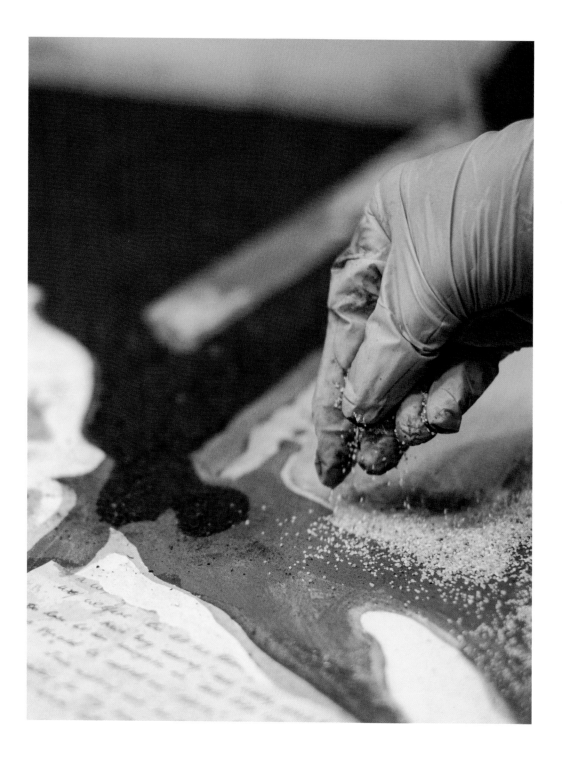

Different tones of the image were colored using the available gamut of soil types and glued down with resin. After the resin hardened, excess soil was shaken off.

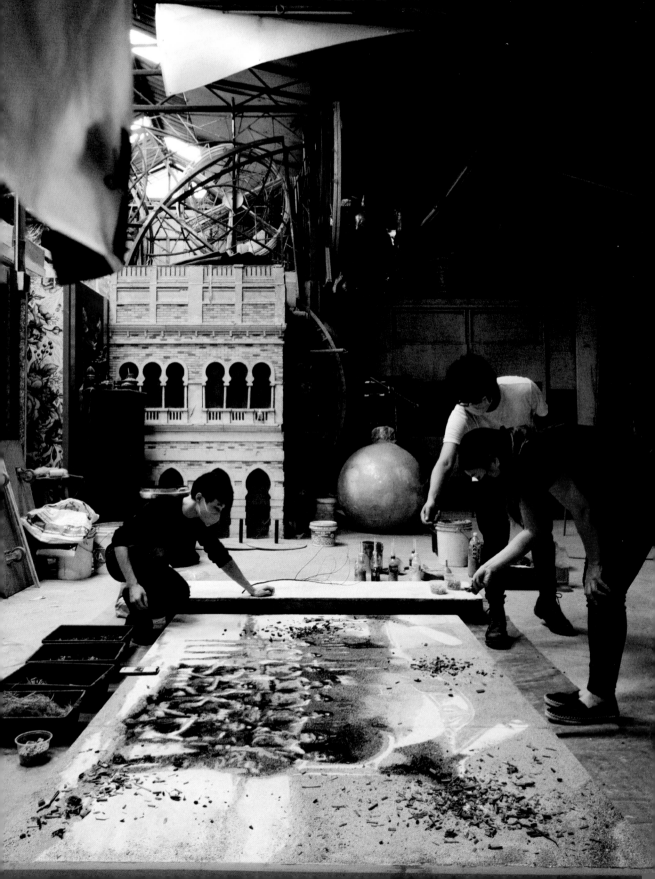

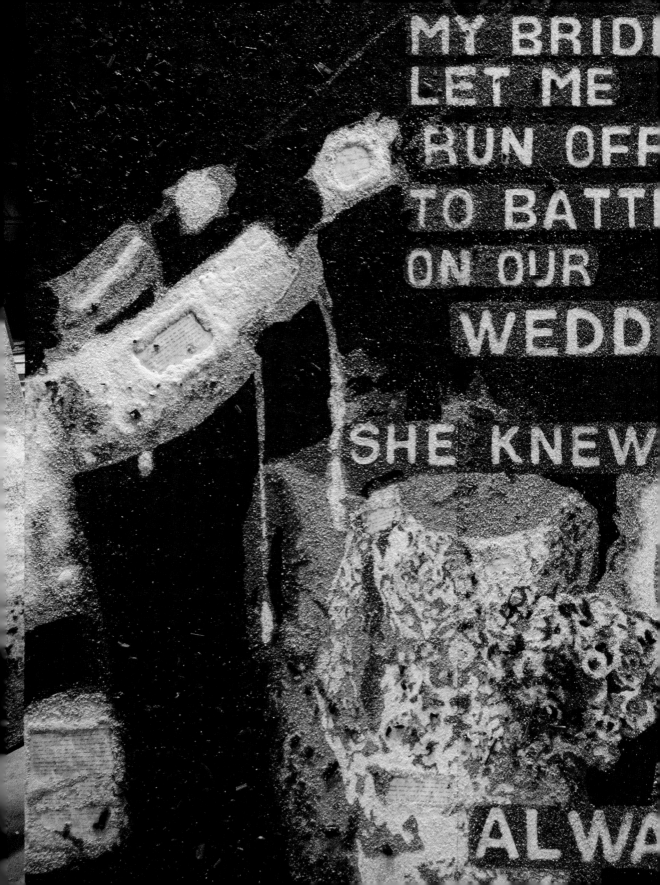

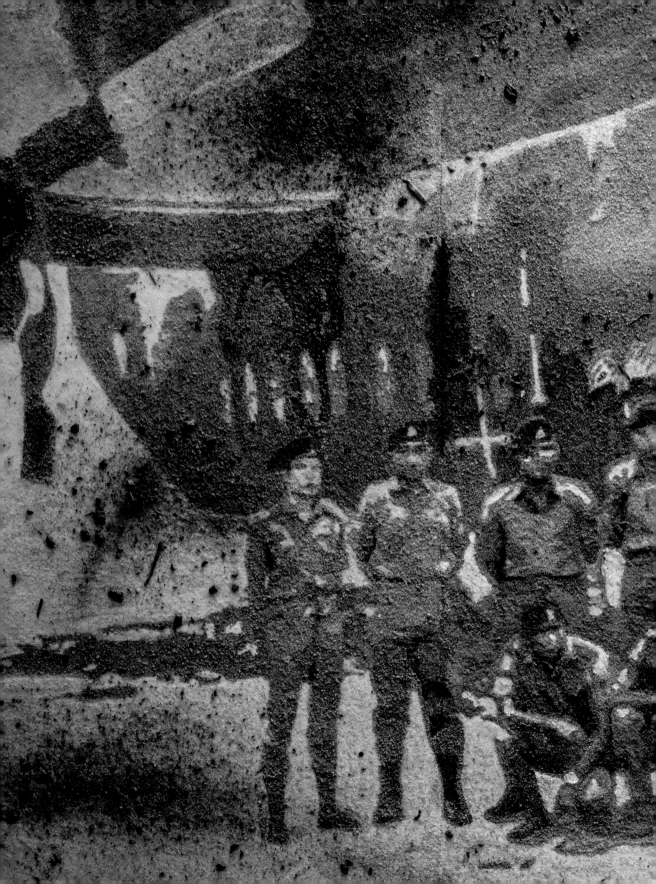

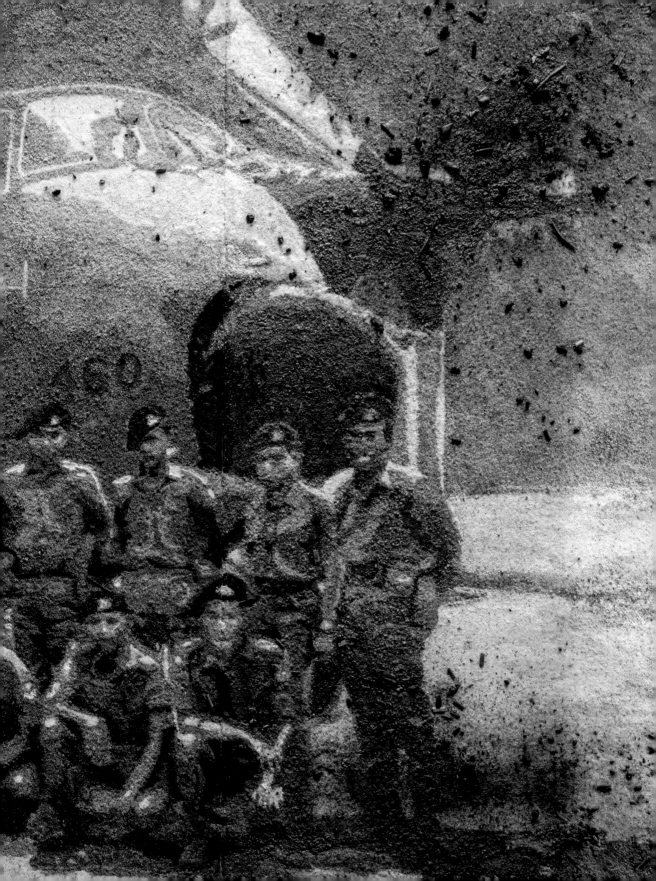

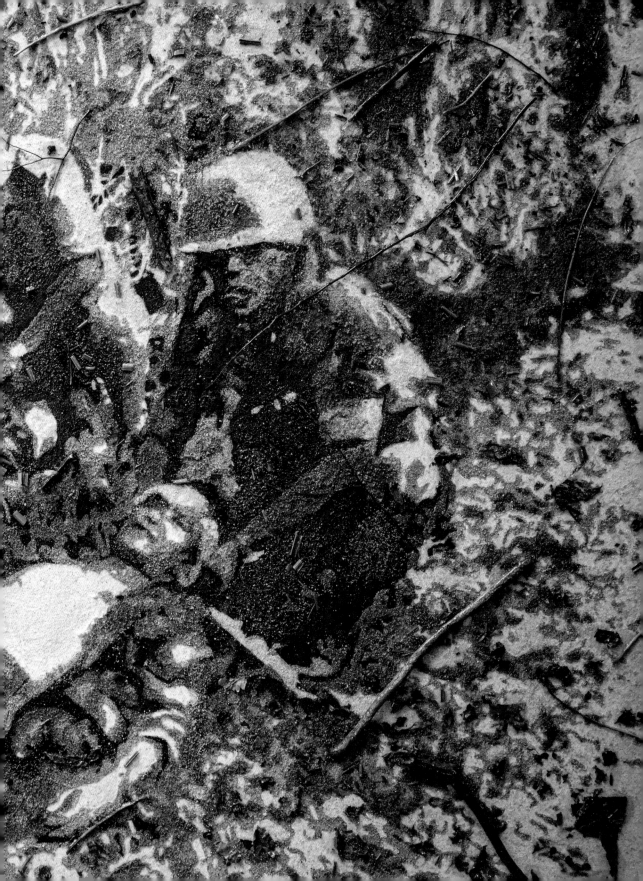

The artwork shown depicts panels with the text:

MY BRIDE
LET ME
RUN OFF
TO BATTLE
ON OUR

WEDDING DAY.

SHE KNEW

MY COUNTRY
ALWAYS CAME FIRST

Tanah Tumpahnya Darah Kita, 2021
Soil and resin on timber board
7.9 × 5.3 feet (2.4 × 1.6 m) per panel

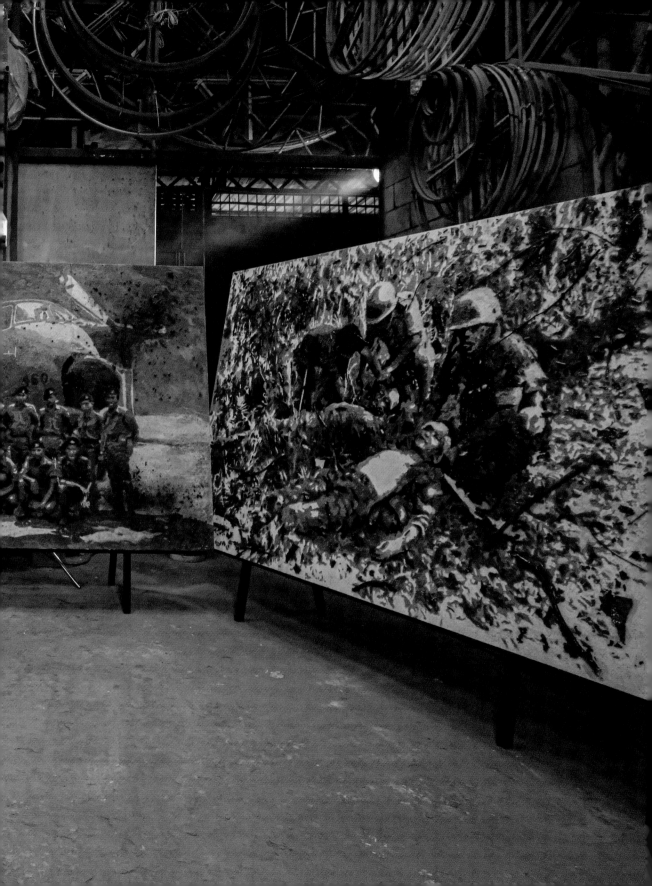

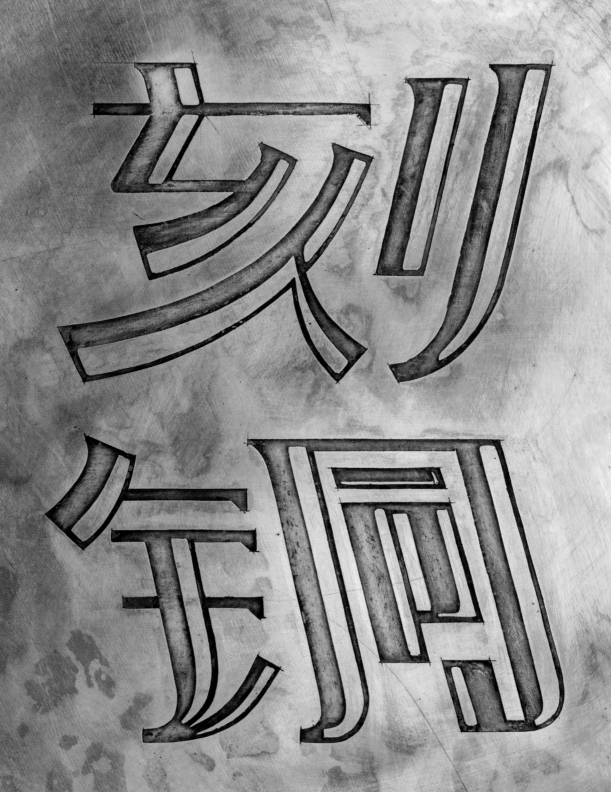

kè tóng

COPPER

The earliest banknotes were found to be from seventh-century China. These were carved out of wood blocks and then printed on paper.

Copper Data

6	large copper plates
1,200	mini prints
18	gallons (70 L) ferric chloride
9	people
8	months

2021

Early Banknotes

Late in 2020, I got to know a circle of friends in the crypto community. "I think I understand blockchain," I said to one of them, trying to sound confident, when they told me about their involvement in this technology. When I got home, I scoured the internet to learn more about the industry. When I told my mother about those conversations, she warned me: "Careful, it could be a scam."

However, after a lot of research and conversations with techies in the space, I learned about the essentials of blockchain technology and the various ways that crypto's decentralized nature offers a more transparent and efficient method of transacting money today. I also learned more about the value of money and the roles of central banks, as well as how economists have warned about the dangers of inflation from the continuous printing of paper money.

I spent months with my team researching blockchain technology, the banking system, and money, and one day, I came across an article about the history of paper money. That was my eureka moment. Paper money, called jiaozi, was developed in China during the Song dynasty in the eleventh century. These notes were printed off a metal printing plate, and jiaozi was a promise by the ruler that one could redeem them later for some other object of value. However, the issue with credit notes was that they were often only redeemable for a limited duration and at a discount of the promised amount.

Understanding this set our team into motion immediately. I came up with the idea of printing our own banknotes using etched plates. We looked into various types of materials that could be turned into printing plates. We first toyed around with using stone, but its weight and brittle nature made us strike it off the list. We also looked into wood and different types of metals, and eventually we landed on copper and discovered that we could create copper-etched plates. We began testing copper etching methods during lockdown by delivering materials to each of our houses, then sending them around to one another for discussion and critiques. Logistically, this was a real feat!

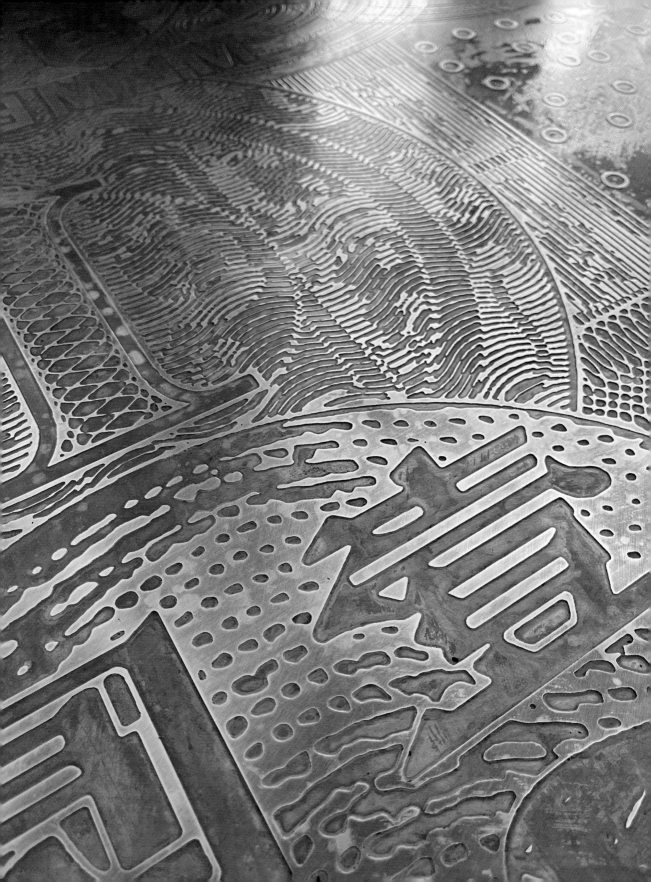

Initially we explored etching our copper plates with laser-cutting machines. However, I didn't want the end result to look too perfect or machine-like. I still wanted an organic and raw quality to the artwork, as if it were an ancient relic dug out from deep in the ground. I envisioned someone many years later digging it up and learning about how our monetary systems today changed with the advancement of technology. After all, I do believe that an artist's duty is to reflect the times we are living in.

Esmond Sit, one of the designers on my team, brought up copper etching with ferric chloride. He mentioned that he had come across it before, but had never actually tried it himself. We immediately got the tools and materials needed and started experimenting.

Traditionally, etching is a printmaking process in which strong acid is used to cut into the surfaces of metal plates to create lines and patterns. This acid only eats into the exposed areas of the metal plate, creating protrusions and recesses; the protruded areas are then covered with ink to create prints with fabric or paper. The depth of the cut lines is determined by the duration the metal plate is exposed to the acid.

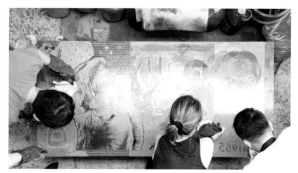

We contacted a metal supplier to test this method on a letter-size copper plate. I found the process of copper etching very straightforward. The tricky part was sourcing the materials and handling the chemicals. When I was confident enough to create our banknote copper plates, I ordered much larger copper plates—six pieces at 62 × 29½ × ¹⁄₁₆ inches (160 × 75 × 0.15 cm) to be precise—because I wanted to print giant banknotes!

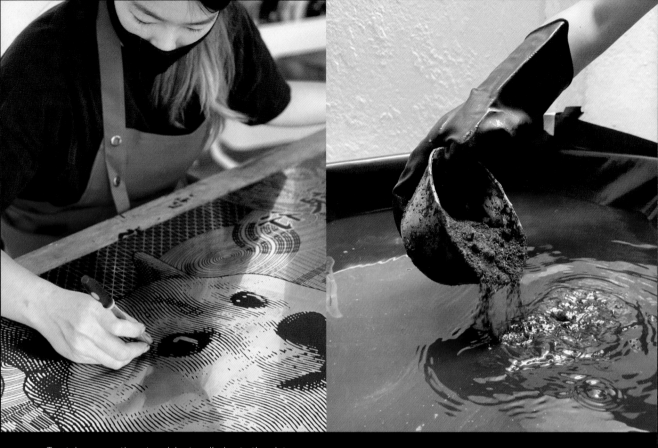

To etch copper, the artwork is stenciled onto the plate, then the plate is soaked in a bath of ferric chloride. Ferric chloride removes copper from any exposed areas. The result is a plate with sunken details of the image's negative.

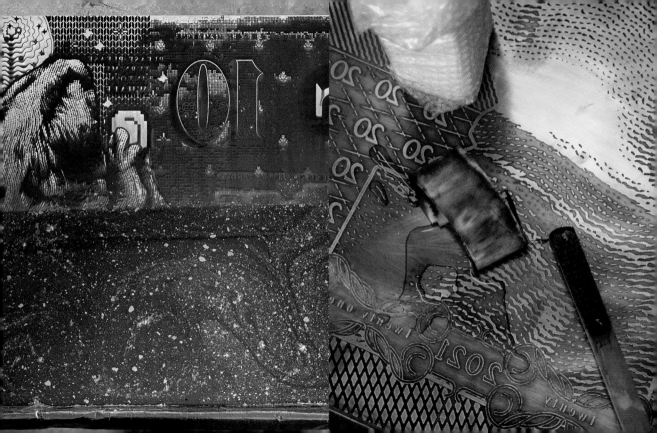

Test-printing freshly etched plates.

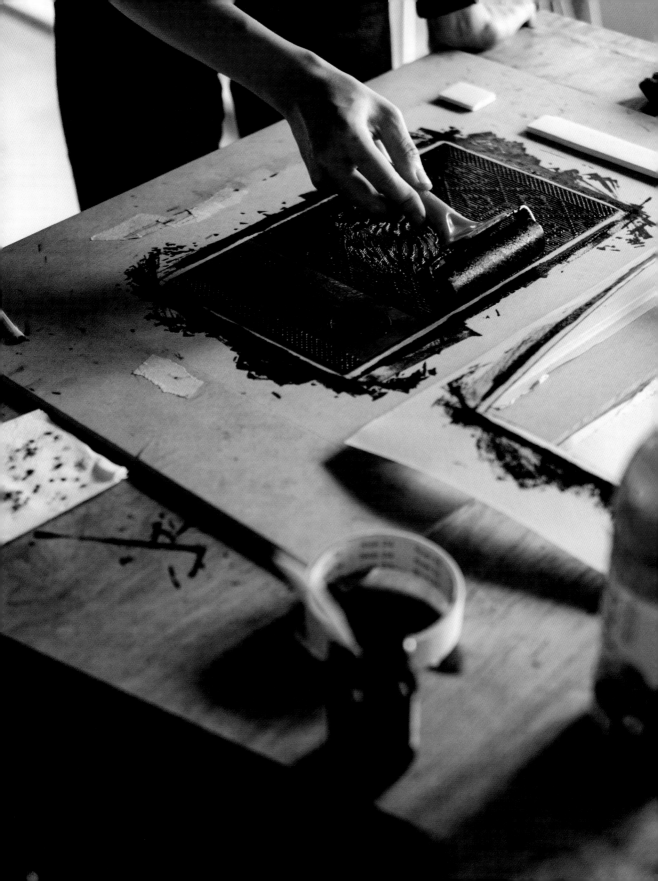

Doge to the Moon

One concern about fiat money (banknotes printed by central banks) is the continual printing of paper currency that economists warn will lead to inflation. This has led to a large community of everyday people seeking alternative investments. This is what my artwork addresses. I wanted to express my observations of traditional systems being disrupted by new technology such as the internet and cryptocurrencies.

My team and I ended up creating six banknote designs, which were inspired by the currencies of six countries: the Chinese yuan, British pound, Japanese yen, Singapore dollar, US dollar, and the Malaysian ringgit. Each banknote also had a central meme character, with the aim to make memes of banknotes and express the virality of memes in the internet age.

The first in the series was *Doge to the Moon*. Doge is a meme of a Shiba Inu, and Dogecoin is a cryptocurrency that started as a joke, better known as a meme coin. There are many symbolic elements hidden in our piece, including the rocket and moon, which refer to the term "to the moon," and show optimism for a stock's rise in value. The number sequence 06122013 refers to the date Dogecoin was created, December 6, 2013. The artwork was produced as printed notes using etched copper plates and was also minted on the blockchain as an NFT (non-fungible token).

The aim of this project was to merge the physical and digital worlds and to critique both our historical and emerging financial systems. The series consists of six unique artworks. Because the banknotes were printed on etched copper plates, I could theoretically print as many as I wanted to, but like an NFT, there will only ever be one master plate.

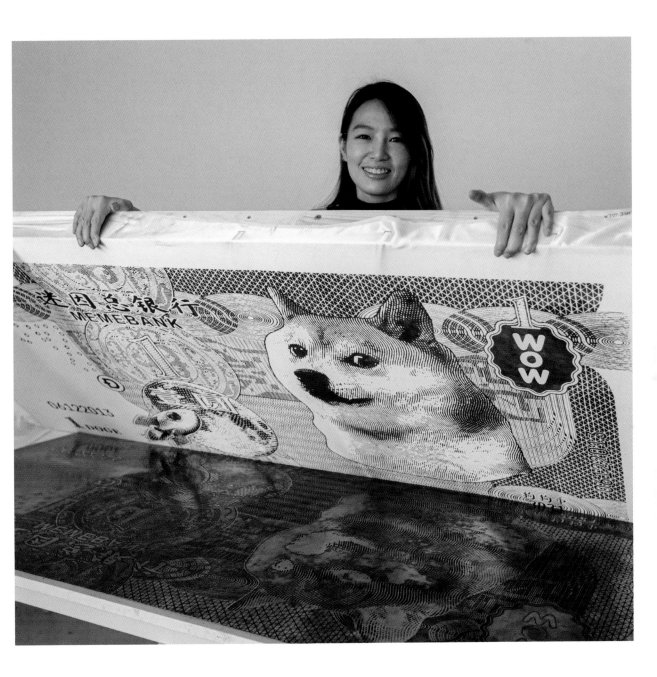

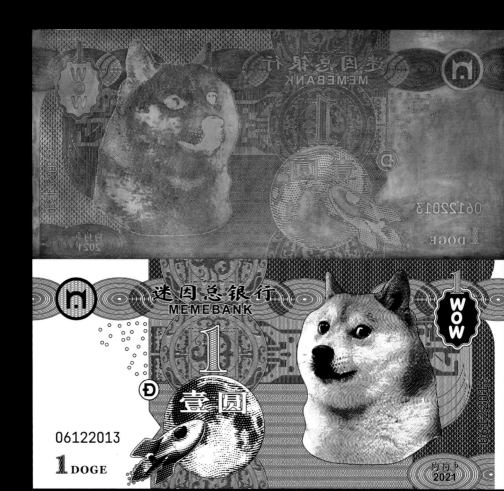

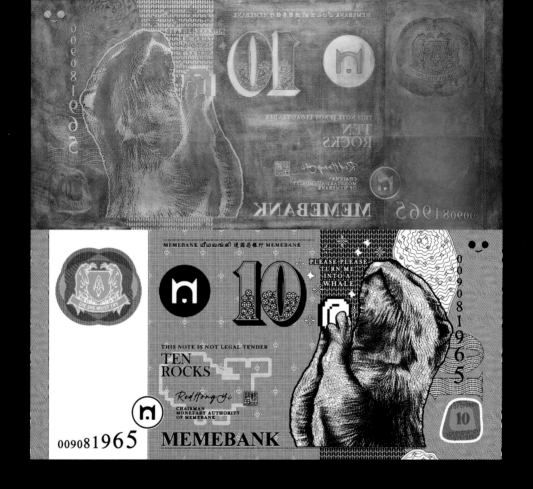

The Praying Otter, 2021
Etched copper, lino ink on canvas
5.2 x 2.5 feet (1.6 x 0.75 m)
Accompanied by a 1/1 NFT sold through OpenSea

The Singapore dollar depicts a praying otter
holding onto a coin. Sharing a popular sentiment
among cryptocurrency buyers, the otter wishes to
be a whale. In crypto terms, a whale is someone who
boasts vast amounts of coins. Otters have in recent
years exploded in numbers in the island of Singapore

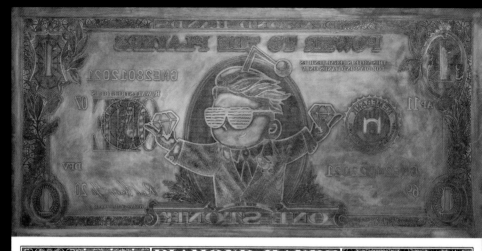

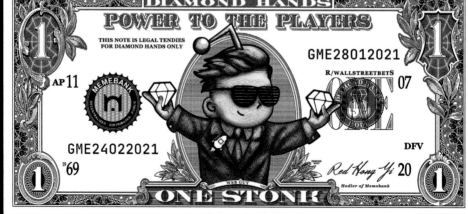

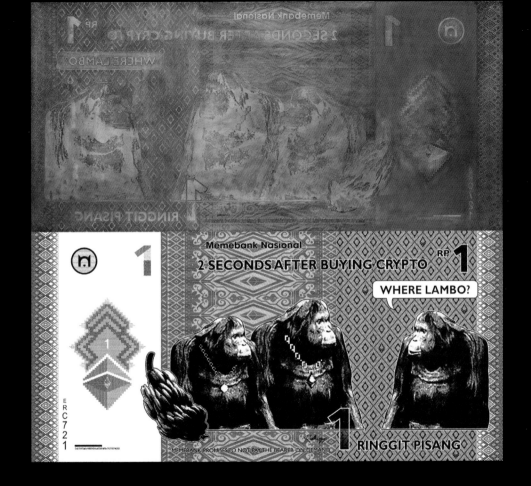

Where Lambo, 2021
Etched copper, lino ink on canvas
5.2 x 2.5 feet (1.6 x 0.75 m)
Accompanied by a 1/1 NFT sold through OpenSea

The Malaysian ringgit features "Where Lambo?"
a depiction of impatient orangutans questioning
when their Lambo—short for Lamborghini—will
arrive after buying cryptocurrencies.

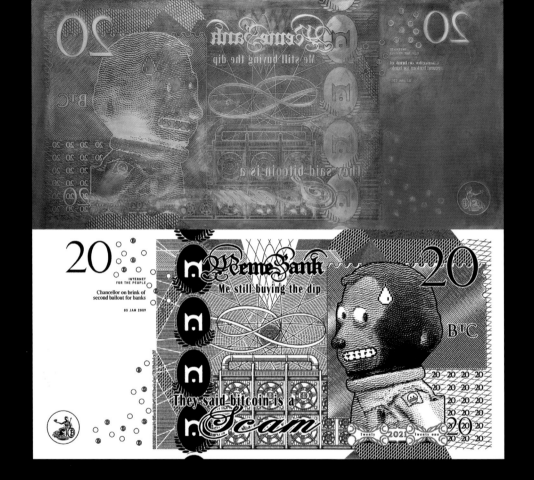

Awkward Monkey Buys the Dip, 2021
Etched copper, lino ink on canvas
5.2 x 2.5 feet (1.6 x 0.75 m)
Accompanied by a 1/1 NFT sold through OpenSea

The British pound features a nervous "Awkward Monkey" that is set against a background with the Bank of England.

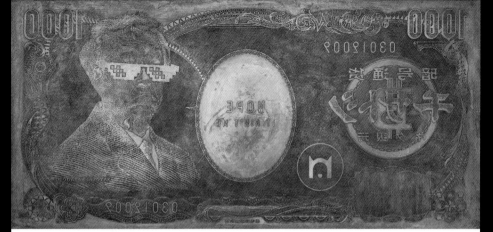

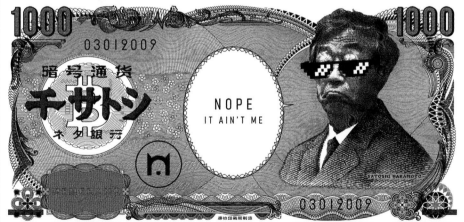

Satoshi Says NOPE, 2021
Etched copper, lino ink on canvas
5.2 x 2.5 feet (1.6 x 0.75 m)
Accompanied by a 1/1 NFT sold through OpenSea

The Japanese yen cheekily shows a man named
Satoshi Nakamoto (the presumed pseudonym of the
inventor of Bitcoin) with the words "Nope it ain't me."

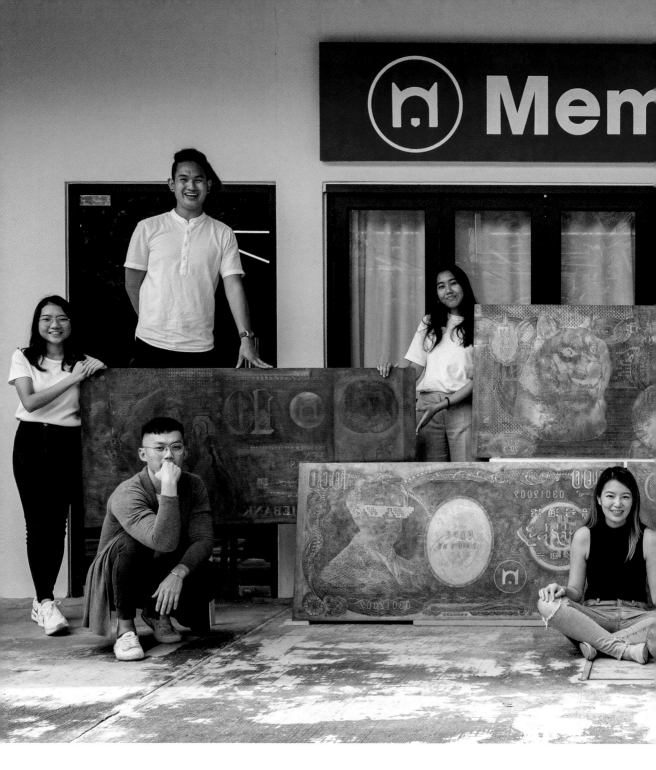

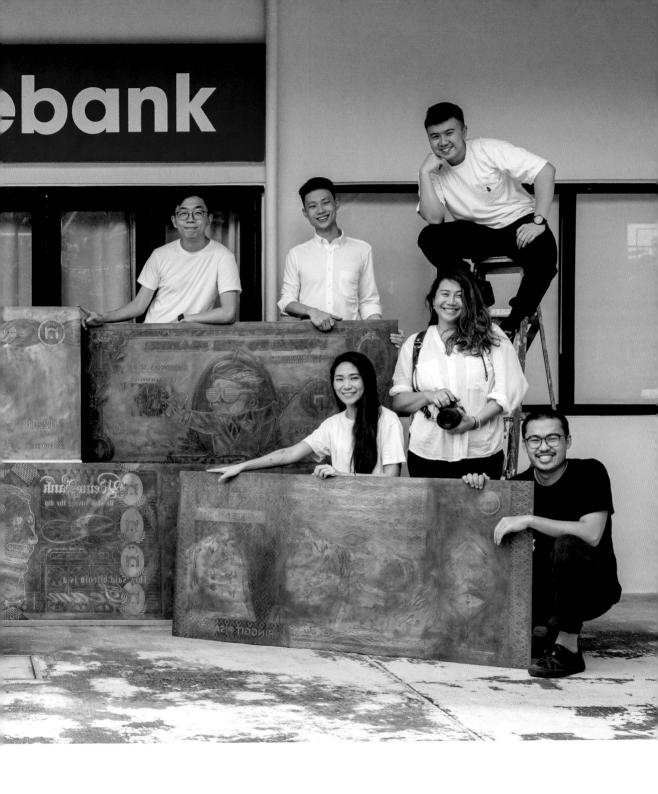

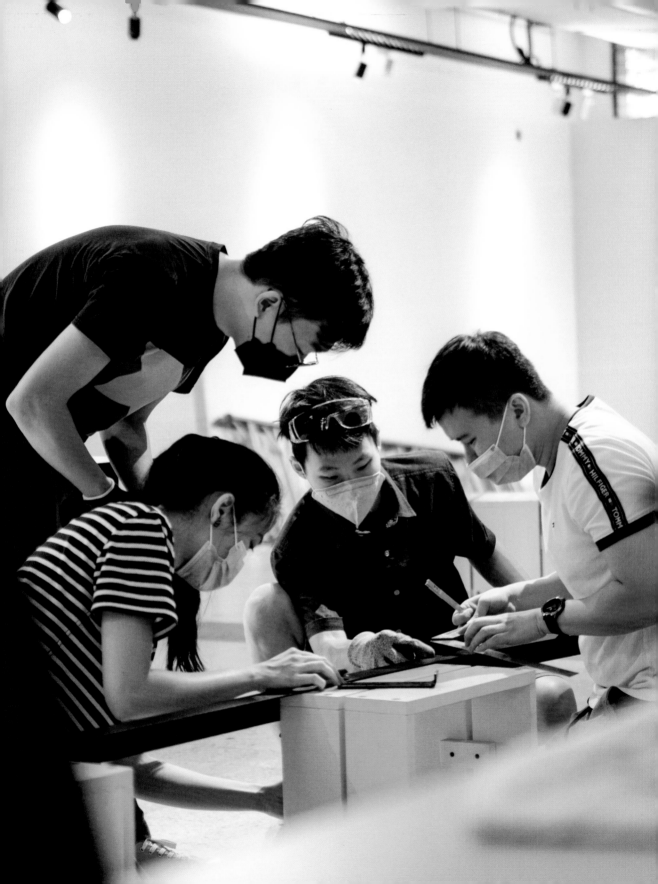

Memebank: The Exhibition

It has always been a dream of mine to organize my own solo exhibition. This was a goal I set for myself at the start of my art career, almost ten years ago, and I decided that there were no more excuses for me to not make it happen with my Memebank project.

When I first had the idea to print banknote artworks, I joked with my team over Zoom that perhaps we could exhibit the artwork in the form of a spoof bank. We laughed, and then I saw the look on my team members' faces. A look that said, "Uh-oh, she's actually serious!"

I funded the entire exhibition through the sales of the six copper plates as NFTs and by linking each of them to the physical artworks; the owners of the NFT banknotes also own the physical copper plates.

In December 2021, we rented an exhibition space at Art Printing Works (APW), a former commercial printing factory established in 1952 in Kuala Lumpur. We scrambled to build a bank, but because we're a team of mostly architecture graduates, we could handle building and designing almost everything from scratch!

Three ATMs were installed on-site, red carpets were laid out, a VIP area with food and snacks was prepared, and a team of fake bankers was placed in charge of printing banknote artwork off etched copper plates. Thousands of limited-edition banknote artworks were suspended from the ceiling, encouraging people to gaze upwards in search of their desired currency.

We had a surprise performance art piece at the closing of Memebank. At six P.M. sharp on the day of the closing, men dressed in shirts with the word REGULATOR emblazoned on them stormed into Memebank. The chairman and CEO of Memebank—me—was arrested, leading innocent bystanders to wonder, *What will happen to my money? Is this all a scam?*

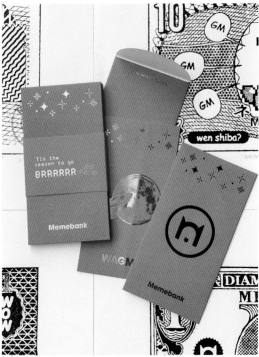

Bespoke red packets made for the exhibition to coincide with the Chinese New Year.

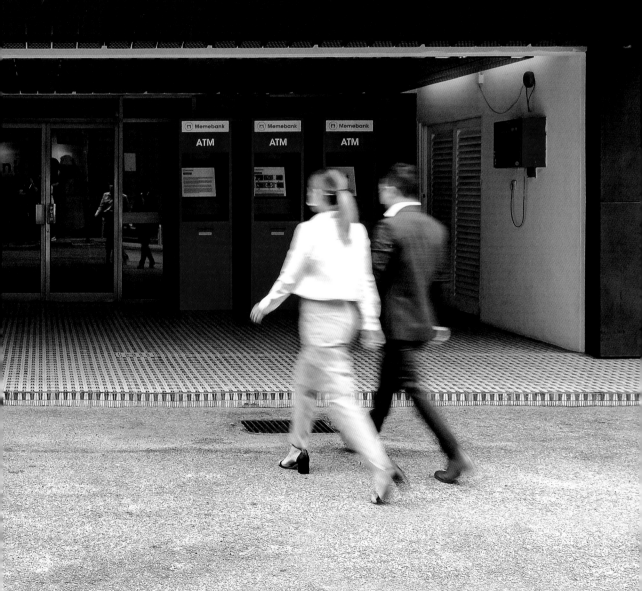

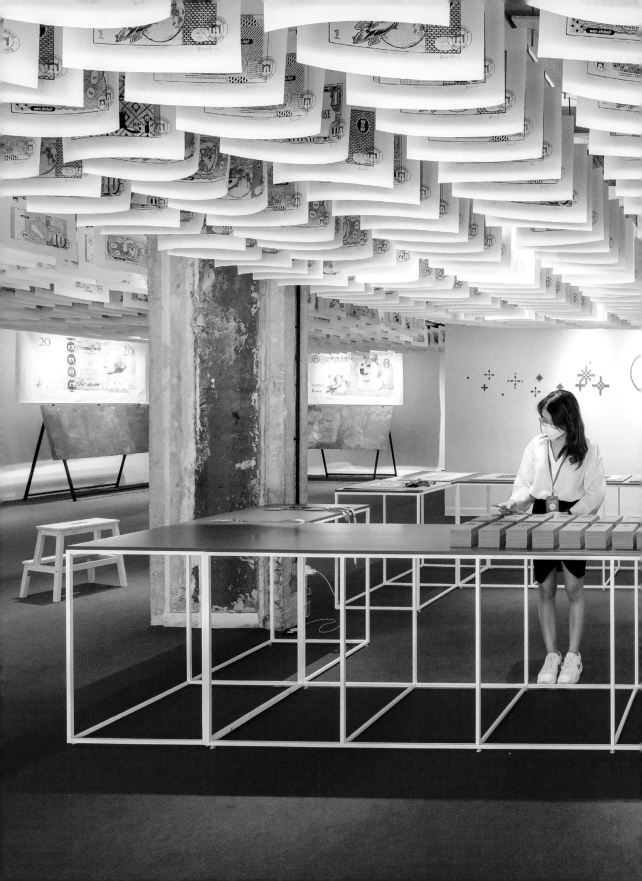

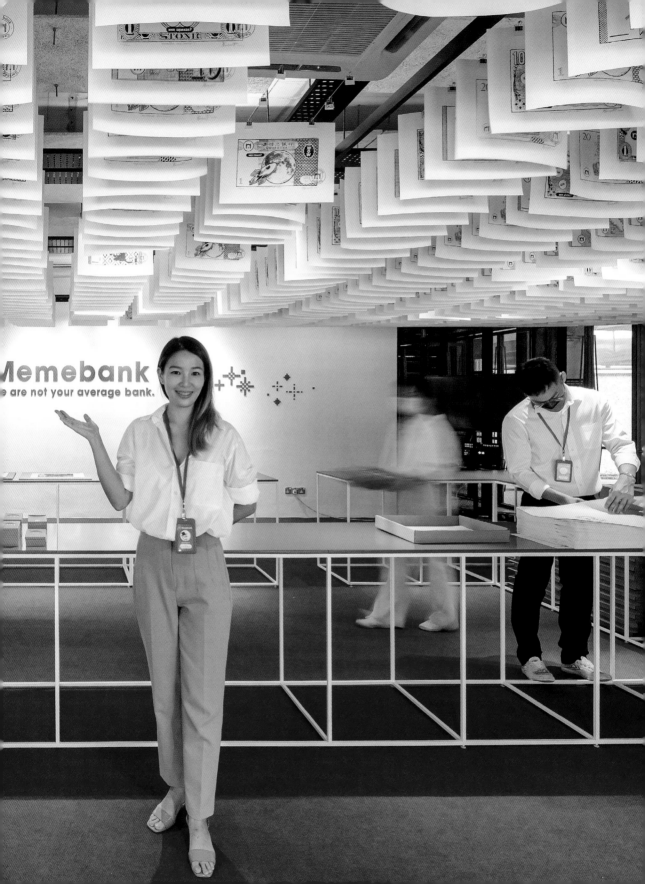

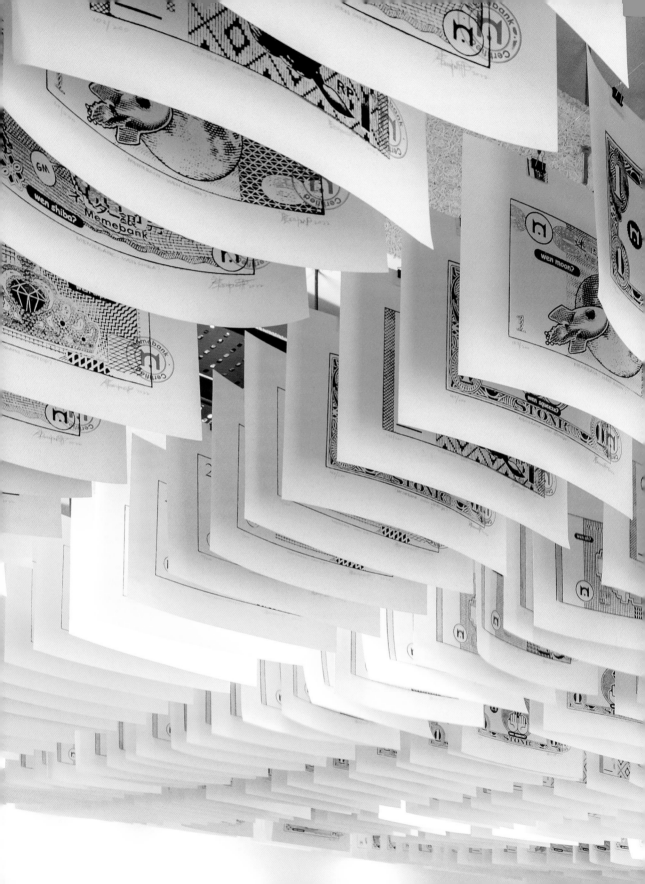

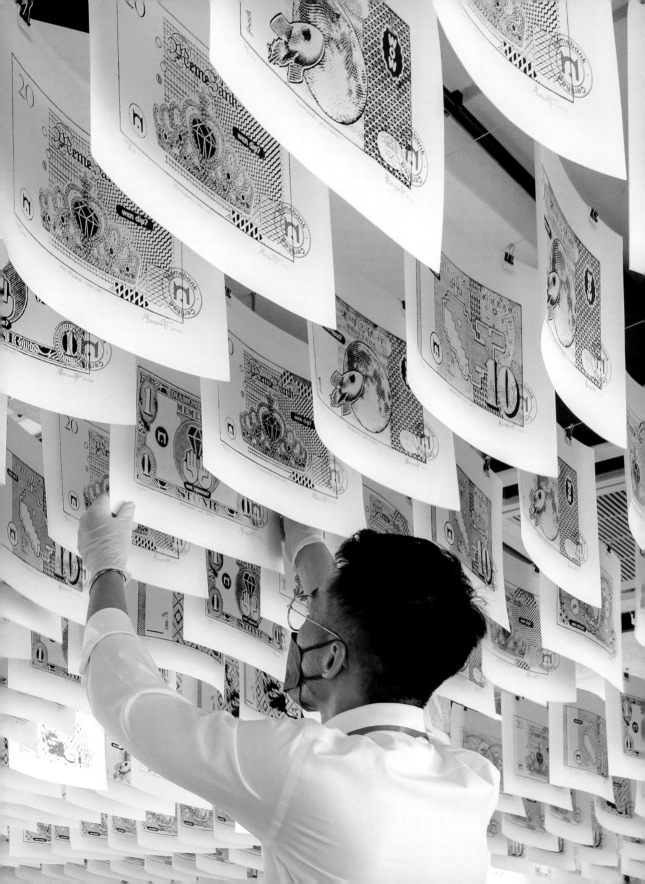

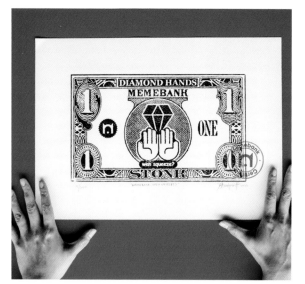

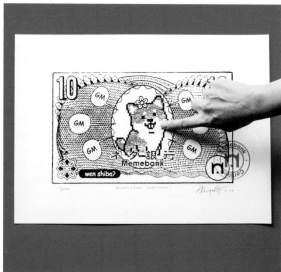

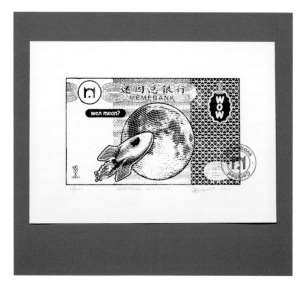

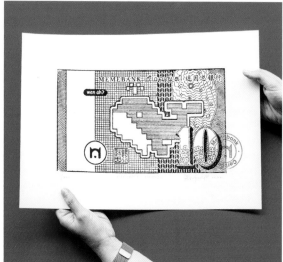

For the exhibition, we created six more mini banknote designs in an edition of two hundred. These mini notes were sold both online and at the exhibition; all the prints sold out and the profits were donated to Mercy Malaysia's Flood Relief Fund.

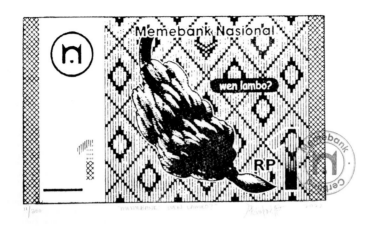

Left:
Banana banknote created
for the Memebank series.

Below:
The actual banana
banknote from the 1940s.

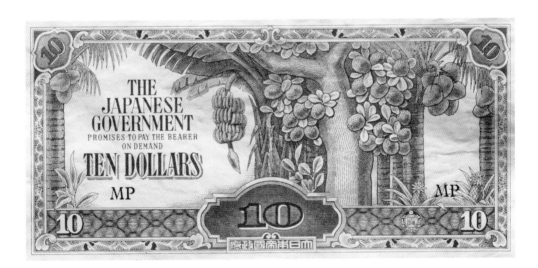

These mini banknotes all had visuals that symbolized something associated with the history of each country's currency. For example, the banana banknote above is dedicated to the Malaysian ringgit. The bananas reference the dollar currency issued by the Japanese during the occupation of Malaya in the 1940s that supplied authorities with money and resulted in hyperinflation and a severe depreciation in the value of these so-called banana notes. "Wen Lambo?" is a line from a meme that pokes fun at those who jump into investments thinking it's an immediate get-rich-quick scheme. "RP" stands for "Ringgit Pisang," or "Ringgit Banana."

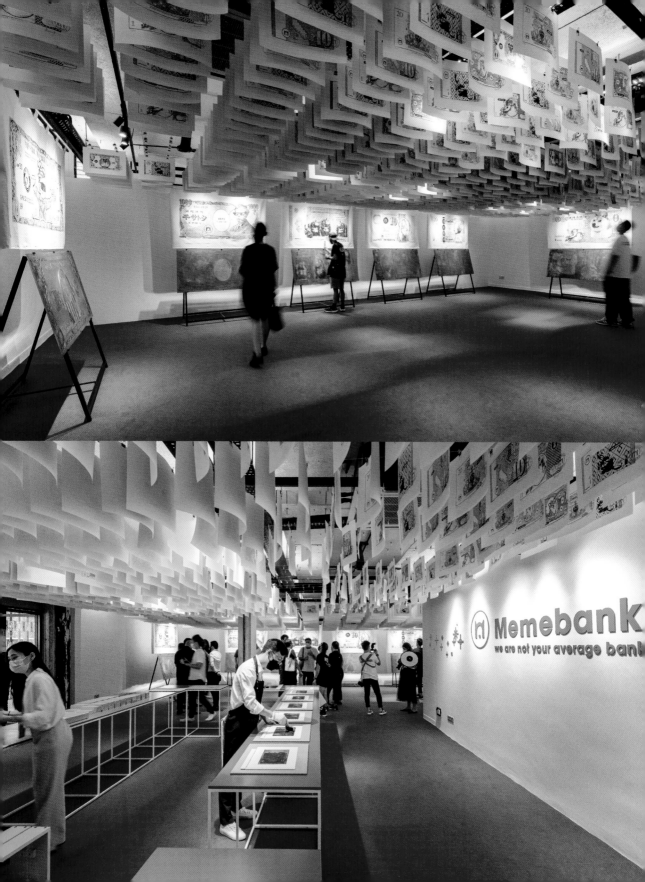

Essentially, Memebank was a parody project mocking how central banks across the world print money, potentially leading to inflation as warned by economists. Everyday people—those who are affected by the printing of money—do not question the economics behind these actions and how it will affect them.

The goal of Memebank was to question the current systems and encourage a deeper awareness of financial literacy and education. I believe that only with more education and awareness can we create more equitable and stable financial systems.

Memebank was the first series of artworks that was self-initiated and self-funded and sold to collectors. This project gave me the confidence to initiate more ambitious bodies of work independently. After Memebank, I plan to pivot the way I work on projects, by focusing on creating personal artworks that discuss current issues and topics that pique my interest, as strange or peculiar as they may seem.

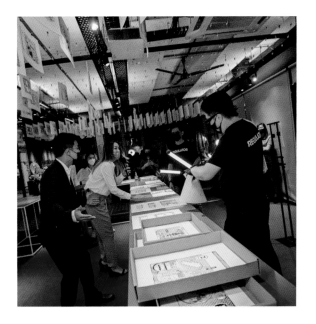

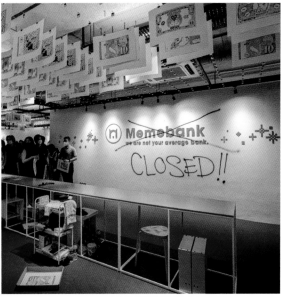

创作小册

chuàng zuò xiǎo cè

Red's Do-It-Yourself Projects

A miniguide to help you create your own art pieces, using seven experimental techniques.

I occasionally get emails from people about how they have experimented with "brushless painting" after seeing my artwork. It makes me happy to hear that people are looking at familiar everyday objects a little differently—and with the realization that anything can be turned into art. Some of the works presented in this book may seem a little complex and daunting in scale and method, but remember that what you see is the final result of my creative process. At the beginning, things start off much simpler. I usually begin with a small "test patch" and experiment with a section or scaled-down version of each piece.

This section has been specially created for you to help you experiment with techniques that have been simplified, are easy to follow, and can be executed with materials that are readily available in supermarkets and art supply stores, or common objects and tools around you. The key is to experiment and have fun!

1. Painting with Soot

煤某
火烟

They say don't play with fire, but sometimes a little risk can throw light onto beautiful discoveries. I first came upon soot when I was experimenting with fire for a commissioned work. The painterly quality of soot reminded me of those picturesque Chinese ink paintings—soft, gentle, and unassuming. I loved how soot allowed me to emulate this style easily, as I could fix mistakes by simply rubbing it off the surface. I hope you have fun with this technique. And be careful—don't burn yourself . . . or this book!

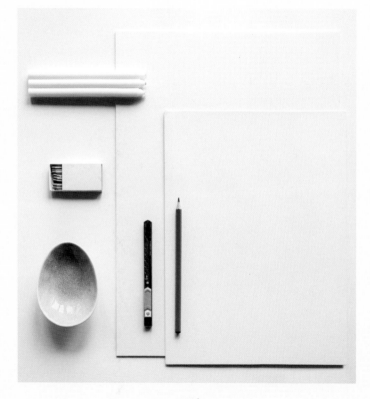

Materials

- Paperboard with glossy surface
- Candles (**Note:** If you can, try to get dripless candles that are made from harder wax with a higher melting point than regular candles.)

Tools

- Pencil
- Blade
- Masking tape
- Goggles or glasses
- Cotton work gloves
- Matches or lighter
- Spray fixative
- Brush (optional)
- Eraser (optional)
- Drip container (optional)

The key to this technique is to use a material with a glossy surface that is not easily flammable. Paperboard with a glossy finish works well to hold the soot. The same material can also be used for making your stencil.

Instructions

Step 1

To prepare your stencil, use a pencil to draw the outline of a tiger, using a reference image. You can also refer to the image on page 208.

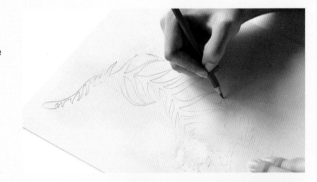

Step 2

Next, using your blade, cut along your drawn lines. Your stencil is ready.

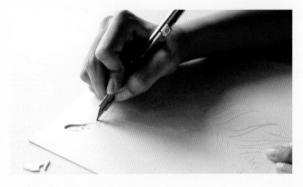

Step 3

Secure your stencil over the board you're sooting on using masking tape. This is to ensure that there are no gaps between your stencil and your base when tilting it at a 45-degree angle. Avoid covering the holes in your stencil with tape as this can interfere with the soot deposit onto your base.

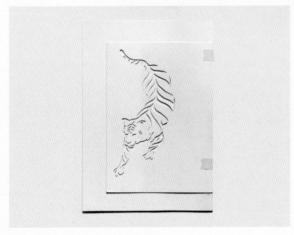

Step 4

Proceed with caution for this step! Wearing your goggles and thick cotton gloves, light the candle and tilt the board at a 45-degree angle. Gently guide the flame back and forth along the lines of your stencil until you get the desired results, keeping the tip of the flame between ¾ inch and 1 inch (2 to 3 cm) away from your base. Take care not to leave the flame stationary in one position for too long as it may burn your artwork. You can use a container to catch the dripping wax.

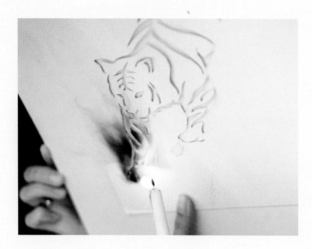

Step 5

When removing the stencil from the base, there may be some accidental smudging of the soot. If this happens, you can use a brush to lighten the smudge or, if desired, an eraser to remove it completely. To seal the artwork, spray a few light coats of spray fixative and let dry.

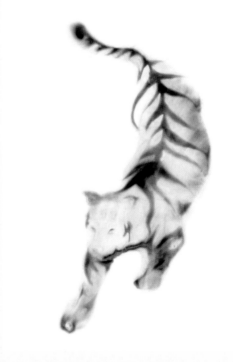

2. Vegetable Stamping

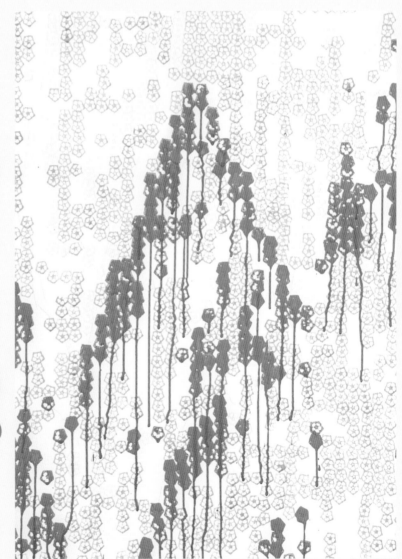

Kindergarten was where I first learned to make print stamp patterns using vegetables. As an adult, it has been a delight exploring how the cross sections of vegetables form pixels and how a proliferation of something so seemingly simple and childlike can grow into something so complex and serene—just like the Japanese and Chinese ink-wash landscape paintings. This project has been a pleasure not only for me but also for the studio. Working on this project reminded us not to take things so seriously all the time and to play with your vegetables!

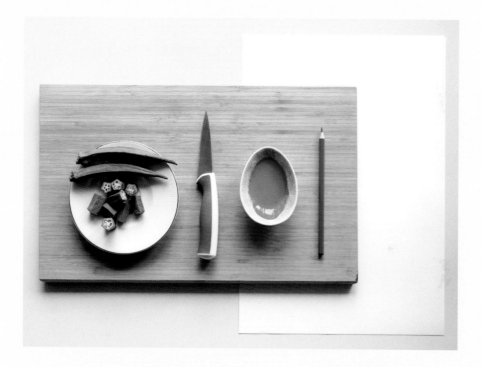

Materials

- Handful of okra
- Acrylic paint (your choice of color)
- A3-size (11.7 x 16.5 inches/ 29.7 x 42 cm) art paper
- Scrap paper
- Water

Tools

- Knife
- Pencil
- Small dish for paint
- Chopping board

Instructions

Step 1

Cut the okra to expose its cross section, pat dry, and set aside. In a separate dish, mix the acrylic paint with an equal portion of water to create the stamp ink.

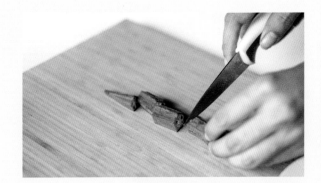

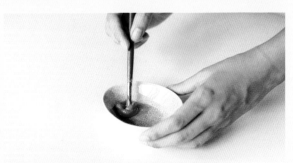

Step 2

On a piece of art paper, lightly sketch out a mountain landscape. You may use the image provided on the right as a reference.

Step 3

Next, dip the cut surface of the okra into the ink and stamp along the penciled outline. You should get a nice inked imprint of the okra's cross section. For better results, stamp the inked okra on a separate piece of paper first to get rid of excess ink before imprinting on the art paper.

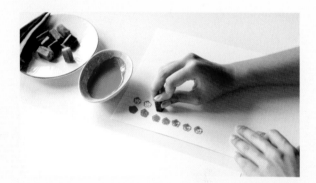

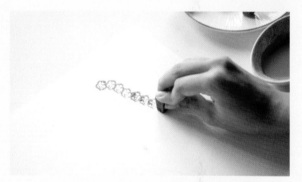

Step 4

For the darker parts of the landscape, make sure that the ink on the previous stamp layer has dried completely before adding a new layer. Densely packed spots will create darker tones compared to more lightly stamped areas. You may also want to explore diluting the ink water for a different effect. Repeat the process and continue to fill up the sketch until you're satisfied!

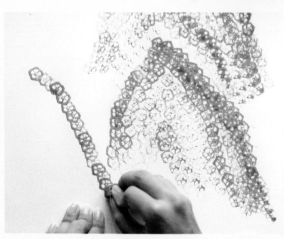

3. Painting with Flower Petals

花与羽毛

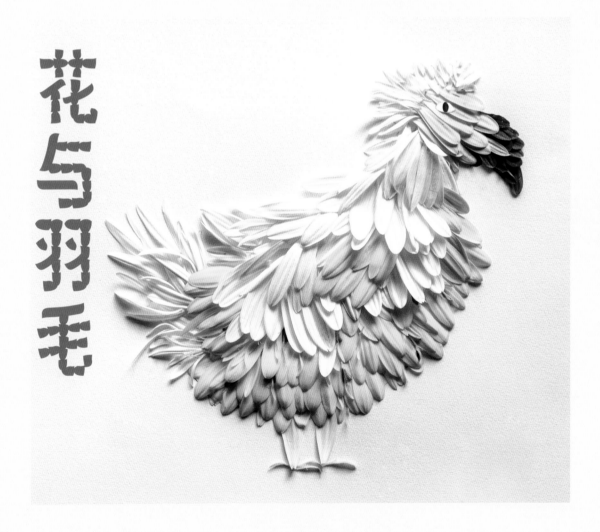

I always thought gerbera petals looked like feathers. Do any other flowers remind of you feathers too? You can use gerberas for this exercise, or feel free to experiment with any other petals that are longer than they are wide.

Materials

- Flowers or dried leaves
- Tabloid- or A4-size (8.3 × 11.7 inches/21 × 29.7 cm) art paper
- White glue

Tools

- Scissors
- Pencil
- Small paintbrush
- Toothpick or tweezers (optional)
- Containers for petals

Instructions

Step 1

Gather an assortment of three or four different flower types. The colors of the flowers will form the color palette of your artwork. For each type of flower, collect about five stalks and harvest only the petals. You may trim the base of the petals with a pair of scissors if you like. Keep the different petals in separate containers.

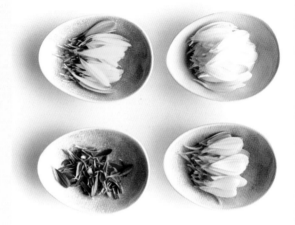

Step 2

On a piece of art paper, lightly sketch the outline of a bird. I suggest outlining the different sections of the bird and assigning each section different-colored petals.

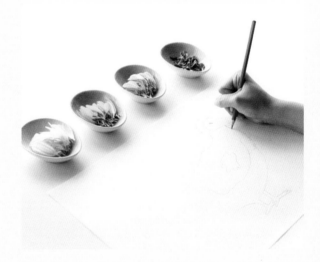

Step 3

Using a small paintbrush, apply a bit of glue to the underside of a petal and fasten it to the paper, repeating the process with the additional petals. Work on filling one section at a time, being mindful of the direction in which the petals are placed. If you find that the petals are too delicate to manage with your bare hands, consider using a toothpick or tweezers to handle them.

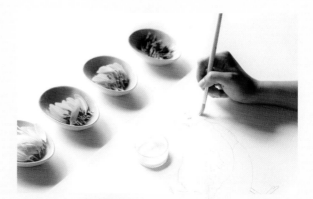

Step 4

Continue gluing petals onto your outline until you have completed "feathering" your bird! This technique requires patience, so set aside enough time for it. Put on your favorite tunes and lose yourself in the process of making art. The great thing about this technique is that you can stop at any time and come back to it, so relax and enjoy the journey.

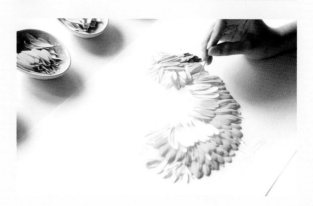

4. Painting with Beans

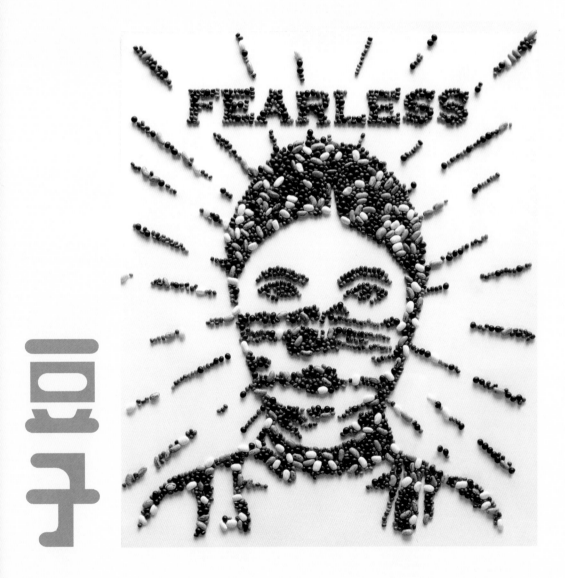

As this book was being written, a surge in anti-Asian hate crimes and racially motivated violence took place across several countries in the West, especially in the United States. This violence was largely driven by the COVID-19 pandemic, and the scapegoating of ethnic Chinese communities by certain political leaders and the media. Day by day, new accounts surfaced of violence and rage toward people who look like me, and this piece was my direct response. While working on it, I was reminded of this quote that was most recently used by activists fighting against oppression: "They Tried to Bury Us, They Didn't Know We Were Seeds." It resonated with me, serving as a reminder to be fearless even in the face of adversity. I enjoy the simplicity and ephemerality of this method. For any artwork made from organic and nondurable materials, I make sure to take good-quality photographs of the work. It's a way for me to always remember the details of the piece. These photographs become the art. Feel free to reuse these beans for other artwork, or you could even make some soup!

Materials

- Beans, grains, or seeds of your choice
- A2-size (16.5 × 23.4 inches/42 × 59.4 cm) cardstock or cardboard

Tools

- Pencil
- Toothpick
- Containers for beans

Instructions

Note: For this technique, you will be exploring size and scale, and the size of your chosen beans will inform the scale of your final art piece. As each bean forms a dot on the canvas, the larger the bean, the bigger the scale of the artwork. For this portrait, a mixture of five beans in varying colors and sizes was used to emulate the pointillism technique. You may use as many or as few types of beans as you like.

Step 1

On a piece of cardstock or cardboard, sketch out the lines of a portrait. You may use the reference image on page 220 as a guide.

Step 2

Gather the beans of your choice and lay them over the outline of your sketch. Using your hands (and creativity!), arrange the beans to fill in the outline, working portion by portion.

Step 3

For the more delicate areas, use a tool such as a toothpick to push and place the beans into the tighter spots.

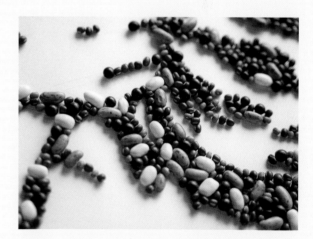

Step 4

Take a photograph of your final artwork, which you can make into a poster.

5. Fish Impressions

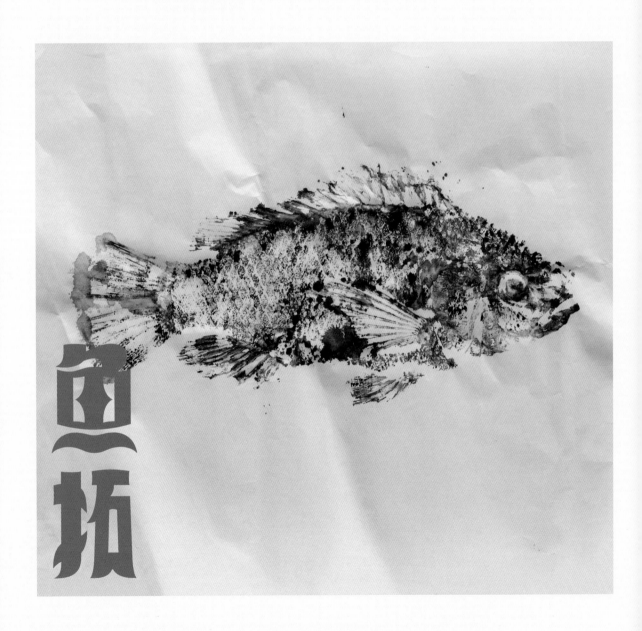

Gyotaku (from "gyo," meaning "fish," and "taku," meaning "stone impression") is the traditional Japanese practice of printing fish that dates back to the mid-1800s. Fishermen used this form of nature printing to record their catches, and since then it has turned into an art form of its own. The gyotaku method of printmaking uses fish, sea creatures, or similar objects as "printing plates," creating unique prints. I explored this technique for a commissioned project and had a lot of fun with it. It can get a little messy, so remember to put on gloves and keep some paper towels handy.

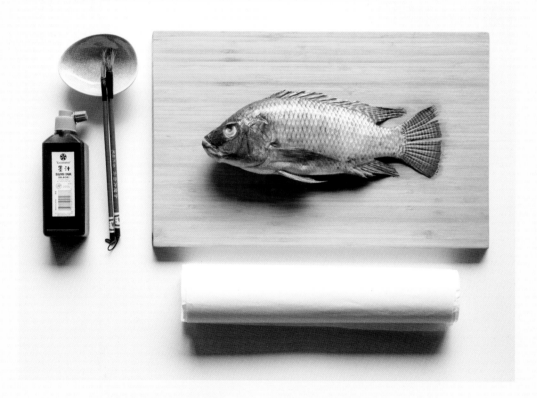

Materials

- Fish of your choice
- Sumi ink or Chinese ink
- Washi paper or plain cotton fabric

Tools

- Chopping board
- Paper towels
- Brush
- Disposable gloves
- Container for ink

Instructions

Step 1

Pat dry your fish of choice with paper towels and gently lay it on the clean working surface.

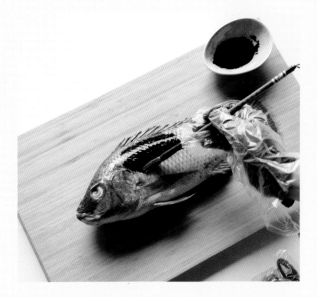

Step 2

Pour a small amount of ink into a dish. With a clean brush, apply the ink onto the topside of the fish. For best results, make sure to be thorough when applying the ink.

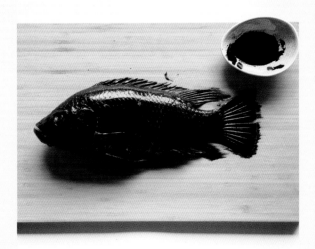

Step 3

Once you have covered the fish in ink, bunch up a paper towel and lightly dab the surface of the fish to remove the excess ink and prevent any bleeding onto the washi paper. This step is a balancing act—dab too little and your print will be blotchy, dab too much and it will produce a very light print. Experiment with this step to suit your creative expression!

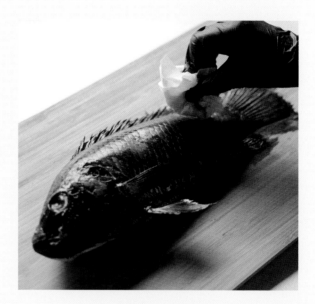

Step 4

Place the washi paper over the fish, being careful not to leave any folds or creases. Massage the paper over the fish to help transfer the ink. When you think you have transferred everything, slowly lift the washi paper from one corner. Well done! You have just made your very first gyotaku print. You can experiment with other types of fish for different effects.

6. Printing with Coffee

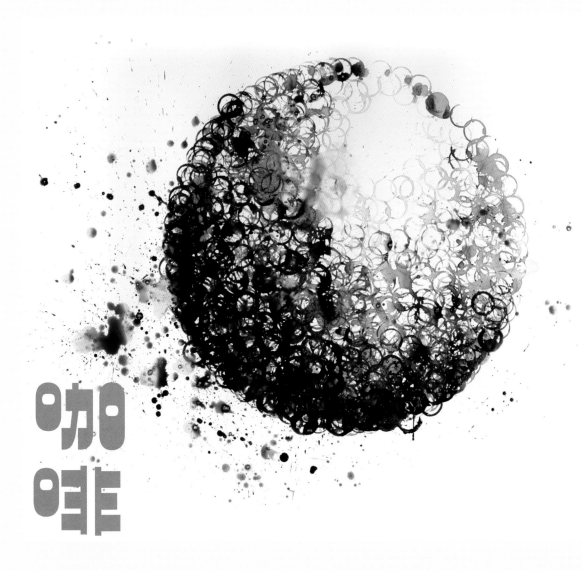

咖啡

As grown-ups, we often view untidiness as a nuisance, and our first instinct is to clean up and put things back in order. But what if we could instead use the everyday messes around us as inspiration to make art? That was what I thought when I saw coffee cup rings on my office desk in Shanghai one cold morning. After a few weekends of experimenting, I came up with this technique of "painting" using layers of coffee stains to create a nostalgic, sepia-toned effect.

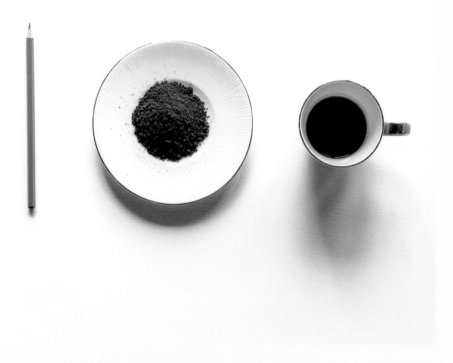

Materials

- Instant coffee powder
- Water
- Art paper

Tools

- Small shallow dish
- Pencil
- Coffee cup or small mug
- Teaspoon

Instructions

Step 1

In a small, shallow dish, prepare the "ink" by mixing instant coffee powder with a small amount of water. Using less water will give you a darker and more viscous solution, whereas more water will give you a lighter, diluted medium.

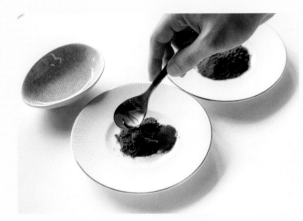

Step 2

On a piece of paper, sketch the outline of an object of your choice. In this example, I have drawn a sphere to echo the circles of the coffee cup rings.

Step 3

Using a small mug or cup, dip the bottom rim into the coffee ink and then stamp it onto the inside of your sketch.

Step 4

Do not worry too much about controlling the ink and getting things perfect; messiness is encouraged in this exercise! For example, stamping with some force should get you a nice, round coffee-stain ring, along with some abstract "splats" that create a beautiful dramatic effect. Repeat the process and continue to fill up the entire shape of your sketch.

Step 5

Voilà! You now have your very own coffee-stain artwork. Keep experimenting by using different-shaped cups and varying shades of coffee, or even tea. More densely packed rings, or overlapping rings, will create darker composition tones compared to more open-spaced arrangements.

7. Eggshell Mosaic

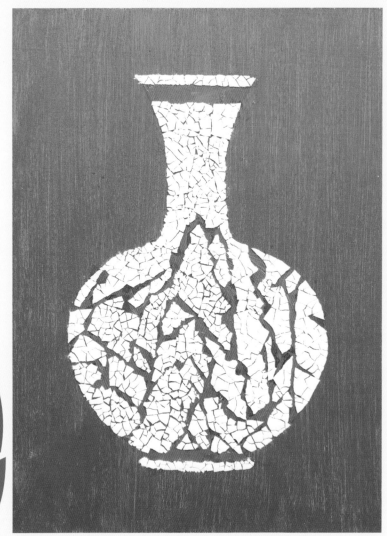

Eggshell inlay has been used by the Chinese, French, and Vietnamese for hundreds of years. My inspiration to explore this technique was derived from going through a difficult personal season back in 2018. During that time, I felt fragile and vulnerable, and the delicate, cracked eggshells provided the perfect vehicle to express these emotions. For this project, I cracked open raw eggs, but some artisans prefer to use hard-boiled eggshells. It's really up to you, but I find removing the membranes from raw eggs much easier.

Materials

- Cracked eggshells from 6 light-colored eggs (see step 1 for cleaning and drying instructions)
- Letter-size wood art board
- 2 colors of acrylic paint (for board and vase background)
- White glue
- Spray fixative

Tools

- Pencil
- Blade
- Toothpicks or bamboo skewers
- 2 paintbrushes

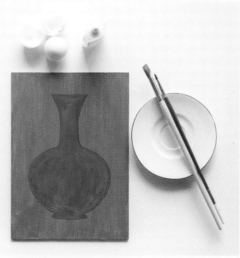

Instructions

Step 1

Rinse the eggshells in water and remove the inner membrane. While waiting for the eggshells to dry, paint over the entire surface of your wood board with the acrylic paint of your choice. Keep in mind that a darker color of paint will contrast with the eggshells nicely.

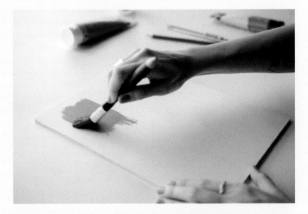

Step 2

Once the paint and eggshells have dried, use a pencil to sketch a silhouette of a vase on the board. The design of this vase is entirely up to you, so have fun and explore different patterns until you find one that suits your personal taste. Once you have your sketch, fill in the shape with another color of paint.

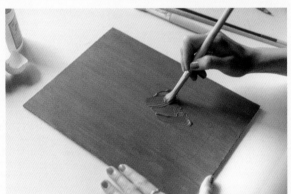

Step 3

Next, apply a light coat of white glue onto a small section inside the vase. Glue dries quickly, and pasting the eggshells takes time, so working in smaller batches is more forgiving. Use your fingers to gently press the eggshell pieces onto the glue-covered surface, laying them as flat as possible. You can experiment with arranging the eggshells exterior or interior side up to create different textures and effects.

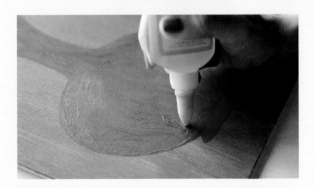

Step 4

As you continue to press the eggshell pieces onto the surface, you may find that one or two will crack and break—this is perfectly OK. Using a blade, you can now separate the smaller pieces from one another, revealing the paint layer underneath. You can use toothpicks or skewers to move these tiny shells around to create finer detailed work on your mosaic.

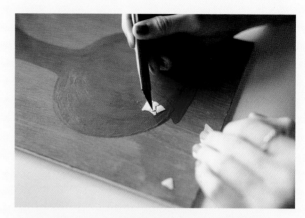

Step 5

Continue filling in the empty spaces of your vase design with the eggshells, playing with their spacing and positioning. This step is time-consuming because you have to look for matching pieces of eggshells to fill in the cracks. At some point, you will need to fill in the gaps with smaller pieces of eggshells, but don't worry too much if you can't always find the perfect fit.

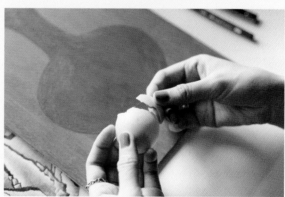

Step 6

Once you have filled in the vase completely, allow the glue to dry overnight. In the morning, seal the artwork with a few coats of spray fixative. This will help ensure that the shell pieces don't fall off, thus preserving your artwork.

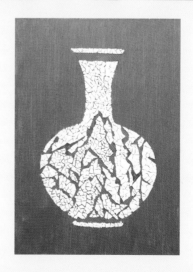

感谢

gǎn xiè

I see this book as a compilation of ten years of experimenting with different types of "brushes." In the next decade, I will be honing in on selected techniques and narratives.

I believe that works of art can bring us together to better understand our similarities and differences. Art may not give us answers, but it will prompt us to ask questions. It can spur thinking and deep emotions, and can also inspire us to take action. I have always wanted to live a life of creativity over certainty; I think life is more exciting and meaningful this way. This is the reason why I do art, and why art brings purpose to my life.

ACKNOWLEDGMENTS

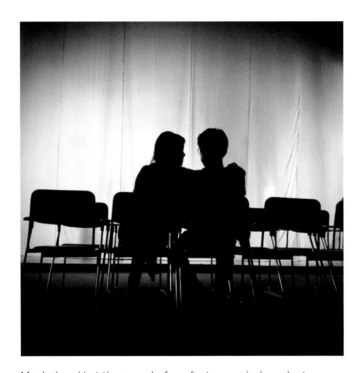

My dad and I at the reveal of my first commissioned art installation in Shanghai, September 2012. This was a three-story installation, and a week before the reveal, I got my dad, who is a civil engineer, to help me with the stability of the structure. I was delighted, but Dad was stressed, as you can see in the picture! Thank you, Bernard Hiew, for capturing the moment.

To my parents, thank you for instilling in me a love for both the arts and sciences. Thank you for taking me on jungle trails and fishing trips, believing in me, and giving me the best childhood companions, my brothers, Ming and Wey.

Shanghai was the city that launched my architectural design and art careers, and I am so grateful to have lived with the best housemates ever, my then-eighty-something grand-aunties Da Popo and Xiao Popo and my grand-uncle Xiao Gong Gong. I also connected with my wider family over many shared meals and learned more about my roots and heritage. I love you all so much.

Thank you to my talented studio team, who I feel so grateful to work with on a daily basis: Esmond Sit, Leong Chee Chung, Wai Chun Yan, Shir Yee Sun, and Kashinie Subramaniam. Many thanks to the studio "alumni," Kaiyi Wong, Shen Phang Lim, and Huiqi Chan, and to Cendana, for supporting the studio through the Apprenticeship Programme grant.

This book wouldn't have come together without the Abrams team, especially Michael Sand and Soyolmaa Lkhagvadorj. I am so grateful to Michael for appreciating the value in my art and cultural heritage and for believing in the potential of this book. Soyolmaa, thank you for being so encouraging about the stories I want to share. Working with you both has been an honor and a dream.

Thank you to the photographers and videographers who documented the many projects in this book: David Yeow, Chong Kern Wei, Annice Lyn, Aaron Wong, Alien Teh, Jonathon Lim, Jessie Lyee, Andrew Goldsmith aka Goldy, Isaac Collard, and many more. I tell people that the most interesting part of each artwork isn't the final art piece but the journey to getting there. I'm grateful to you all for documenting my journey and process.

Valen Lim and team, thank you for helping me with the design and layout of this book and for accommodating so many changes! I especially love the font design of these chapter dividers. Rachel Ng and Beverly Yong of RogueArt, thank you for your insights and feedback on the text, content, and flow of this book. And thank you Lim Su Lin for copy editing the draft with the studio team.

Thank you to Aggie Ye, Joel Lee, Hong Ming, Bernard Hiew, Samuel Koh, Mond Qu, Jannette Le, Michael Mack, Rachel Mui, Nee Wong, Vess Bong, Joy Chih-Yu Chang, Kenji Chai, Danielle Soong, Venice Foo, Elicia Lo, Wilson Ng, Alvin Chung, Yu Hua Liew, Joanne Chin, Mel Lo, Chuah Chong Yong, Liza Ho, Ryan Chen, Rodney Koh, Ling Yah Wong, Sue-Ann Wong, Harrie Pillay, Kenny Gan, and the London Speaker Bureau team, and everyone else I have ever worked with.

Joon J. S. Park, you have been and are an inspiration to me. Thank you for making me feel seen with your writing and your friendship.

Thank you to Michael Hawley and Nina You, who I think of and am thankful for every day. Michael reached out to me when I had just begun sharing my artwork ten years ago, and his belief in me and my art, as well as the conversations with and insights from him, changed my life. I believe he is continuing to change lives through his influence and through his beloved Nina and Tycho.

Joe Lee, thank you for co-conspiring with me, and for your belief, encouragement, patience, and wisdom. I look forward to more adventures with you.

Finally, I want to thank all of you who follow my work and believe in me. This book is your book too.

Editors: Michael Sand and Soyolmaa Lkhagvadorj
Designer: Valenlim Studio
Design Manager: Darilyn Lowe Carnes
Managing Editor: Annalea Manalili
Production Manager: Denise LaCongo

Library of Congress Control Number: 2022942354

ISBN: 978-1-4197-6195-9
eISBN: 978-1-64700-674-7

Printed and bound in Malaysia
10 9 8 7 6 5 4 3 2 1

Abrams books are available at special discounts when
purchased in quantity for premiums and promotions as
well as fundraising or educational use. Special editions
can also be created to specification. For details, contact
specialsales@abramsbooks.com or the address below.

Abrams® is a registered trademark of Harry N. Abrams, Inc.

ABRAMS The Art of Books
195 Broadway, New York, NY 10007
abramsbooks.com